Sandsong

For Nancy & Brad
with warmest wishes
for a happy life together—
J. Lymos.
5/93

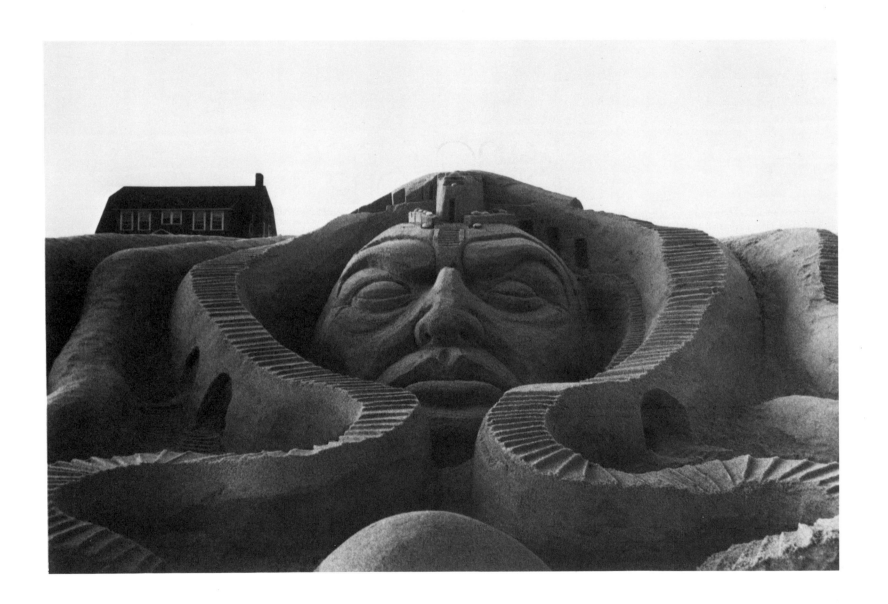

Sandsong

Ephemeral sculptures by G. Augustine Lynas

Edited by Marilyn Meyers

St. Martin's Press

Important message to the reader:

Sand sculpting can involve prolonged, strenuous effort and therefore requires a high level of physical fitness.

We recommend that it be tried only after a thorough medical examination and with the consent of a qualified physician.

Accordingly, the publishers and author accept no responsibility for the consequences of any attempt to construct any sand sculpture shown in or inspired by this book.

SANDSONG/EPHEMERAL SCULPTURES BY G. AUGUSTINE LYNAS

Copyright © 1983 by Gerald A. Lynas. All rights reserved.
Printed and bound in Hong Kong by South China Printing Company.
No part of this book may be used or reproduced in any manner
whatsoever without written permission except in the case of brief
quotations embodied in critical articles or reviews.
For information, address St. Martin's Press,
175 Fifth Avenue, New York, N.Y. 10010

Library of Congress Cataloging in Publication Data

Lynas, Gerald A.
Sandsong

1. Lynas, Gerald.
2. Sculptors—United States—Biography.
3. Sand sculpture I. Title.
NB497.L9A2 1983 730'.92'4 83-3049
ISBN 0-312-69915-8

First Edition
10 9 8 7 6 5 4 3 2 1

Book design: G. Augustine Lynas
Typesetting: VIP Typographers Inc., K.C., Mo.
Book agent: Wecksler-Incomco, N.Y.C.

Introduction

As a young boy, I made little sculptures of clay dug from the wooded hills near our home outside Washington, D.C. There were animals, people, miniature houses and furniture, chess sets, entire circuses. Now I am forty years old and make my living as a graphic designer and art director in New York City, but the boy who made those clay worlds is still alive and working. Beaches everywhere invite me.

I have been making sand sculptures as a serious hobby for many years, and my enchantment is continual. The materials — sand, water — are plentiful and free, allowing me the luxury to build enormous public works and to interact with an always changing audience as they view and judge the results of my imagination. The work, emerging against a limitless horizon, has all the freedom of pure play. Creative interaction with the sea and my experience of the gradual dissolution of each piece has taught me the beauty and power of the fourth dimension of Time.

In 1981, with the help of many friends and generous contributions, Stuart Goldman, my business partner, and I were able to make a short documentary film entitled *Sandsong*. It recorded the building process and eventual destruction of a major sculpture at a beach on Fire Island, New York; it also showed several older works in a retrospective glimpse into the variety of subjects which this magically versatile medium can sustain. This book evolved from the film in an attempt to give readers a broader view of the subtleties and pleasures of sand sculpting.

Unless otherwise indicated, the photographs are my own, representing works created primarily in the continental United States over the past eight years.

The book is organized into three sections: Sand Sketches; Major Works; and a color portfolio. I had given some thought to the idea of making a separate "how-to" section, but realized that there is enough information throughout the text for the interested reader to make a go of it. The principles I apply are learned mostly through trial-and-error, although there are many references to established and commonsense techniques. Any of you who has ever attempted to make a sand castle knows some of them. Others will develop from your own "original" discoveries. The joy is in that experience.

The section on Sand Sketches covers minor pieces usually created with little or no pre-conception, and built in small scale and/or very little time. The Major Works section represents large-scale sculptures requiring huge investments of time and physical energy; some measure as much as 38x20x6' and involve the re-arrangement of tons of sand and water. Large pieces can easily demand up to twelve hours of intensely concentrated labor. In the color portfolio, which contains both major and minor works, I felt the color better conveyed not only the passage of time, but also the mood of the environment, that being frequently the most dynamic aspect of the whole beach performance.

I wish to express my gratitude to so many people not named here, who have encouraged me to pursue this project; and in particular, to Marilyn Meyers for her invaluable editorial contributions and the constancy of her support and friendship.

Sand sculpting has given me years of creative, emotional and physical satisfaction; I hope that you, the reader, will share in that delight. I dedicate SANDSONG to my wife, Ines, and to my daughters, Tamara and Sarah, and to the children in all of us.

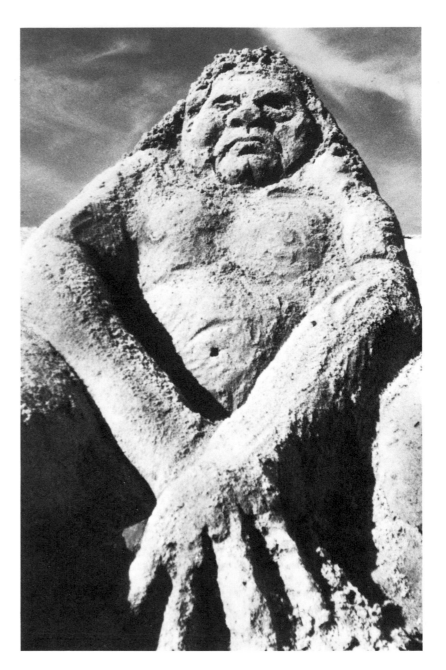

Buddah *4x5x5'*

Built in about an hour,
this overweight fellow
looks huge from a low camera angle.
A thick neck and cascading hair
provide structural support for the head.

6

Sand Sketches

A beach is a wonderful playground. But for me, it is also an immense source of irresistable raw material. On a beach, my instinctive response is to fall to my knees, scoop up a pile of moist, smooth sand with my hands and forearms, and shape it into anything which happens to come to mind. Often, it is a face or a human or animal form . . . things most familiar to me. Sand sketches are created in just this way: on the spur of the moment, in a burst of energy. Some, such as on pages 9 or 28, took only a few minutes to construct. Frequently, as I hurriedly assemble a mound of raw material, the random arrangements of peaks and valleys will suggest something to me and the sketch evolves in response to that.

In sand sketching, I investigate all the traditional elements for judging the work in progress: composition, play of light and dark, subject matter, textural interest, movement, color, and the effects of time. Sometimes, I do studies of anatomy or facial expressions, or I work on engineering principles. Perhaps it is an occasion to experiment with the use of other materials such as shells, sticks, seaweed, stones, water pools; or to toy with city planning and architectural design. Sometimes I don't think at all and let the sand carry me through the wonder of free association.

But before the spontaneity takes over, I've checked for the two essential pre-conditions which assure strength and stability: good moisture content and sufficiently clean and fine textured sand. Working near the tide line usually provides both elements.

It is also important to determine the direction of the tidal movement so that you can work having some idea of the life span of any given piece. If you work at the high tide line, marked by natural deposits of the sea, and the tide is going out, you will have about twelve hours before the ocean moves in to reclaim its position and your sculpture. If you race against a rising tide, as was the case in many of these sand sketches, the life of a sculpture may be only momentary.

Some of these pieces, as on pages 22 or 32, were designed specifically for the sea's inevitable interaction. A kind of "instant antiquation" takes place as the sculptures seem to age thousands of years with the touch of a single wave. As this metamorphosis occurs, many onlookers, some silent for long stretches of time, tell me they are sad at the sculpture's demise. But for me, the beauty of this phase supercedes any sense of loss. Each work, especially a minor one, is a learning experience, a collaboration with impermanence. The sculpture, alive and changing, re-arranges itself in the sea. And, I am free to make another one tomorrow.

The fundamental techniques are simple. Pile up some wet sand, pack it very tightly, then smooth out the surface with a flat object such as a board or Frisbee®, and begin cutting with a sharp device: a shell or stick. The more tightly you compress the sand, the longer it retains moisture and the easier it is to carve vertically. In some cases, tightly packed sand will even sustain undercutting, bridging or tunneling. Undercutting is important in casting strong shadows which give good definition to edges. Ultra-smooth surfaces, as on page 17, lend the illusion that a material other than sand has been used. These hints don't necessarily guarantee good sculptures, but they are the foundations of many of the sketches and I frequently rely on them.

These quick pieces lack one ingredient vital to making impressive public beach art: volume. A large-scale sculpture immediately draws you in through sheer size, if nothing else. In a minor work, I tend to compensate for that missing element through content and detail. A putty knife or plaster spatula can give fast, clean results, and is useful for creating inorganic structures or designs with straight lines. I find, however, that these tools are inhibiting when working on more organic forms; physical contact with the sand generates a much better dialogue. I can feel how the material is responding, changing.

At this point, I must give credit to my favorite sculpting tool — the flying disc — which most people refer to as a Frisbee®, one of many brand names. I've been a devotee of the art of the disc for years, and at the beach it is my constant companion. Aside from its traditional uses, it is the ideal instrument for scooping, compressing, smoothing, carving, scalloping, decorating, and for collecting water, shells and stones. If you are making a sand sketch which doesn't require piling large quantities of sand, the disc may be all you need. And when you want to stretch and loosen up from the sometimes contorted positions required in sculpting, playing with the disc — even alone — provides invigorating relief.

Although I have made many more sand sketches than major pieces, they usually go unrecorded as I am less likely to have a camera with me when the mood to build strikes. It is also less likely that a small work will survive accidental destruction or vandalism while I run off to get photographic equipment. Finally, the sketches are created not for the camera, but for passersby to enjoy at the immediate moment, much as they might enjoy listening to a brief melody carried on the wind.

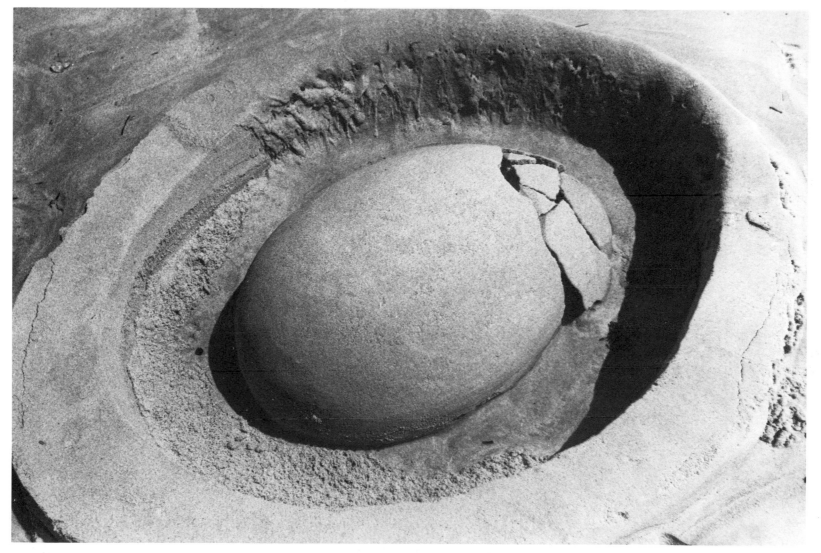

Three Minute Egg *3x4x1'*

The convex side of the disc smoothed the shell surface in a few moments.
When the first wave jumped the framing wall, the egg cracked.

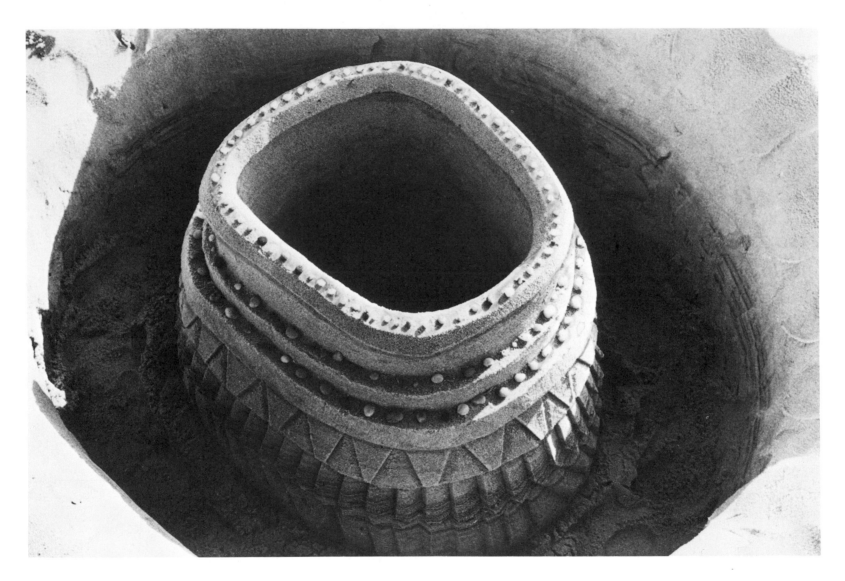

Small Urn *3x3x4'*

A good technique for making vessels: Dig a hole, then excavate a moat around it.
No compression is needed. Cutting with a spatula creates clean, sharp details.

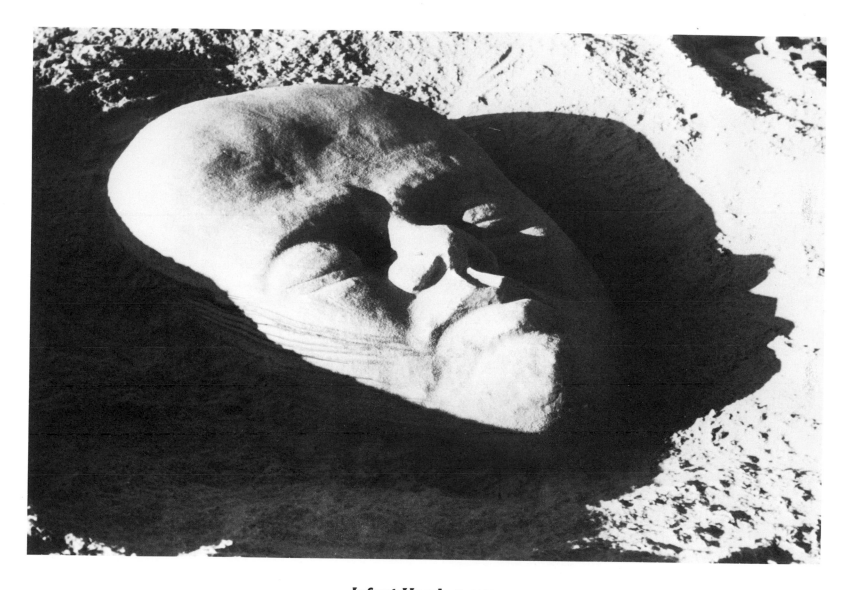

Infant Head 5x4x2'

The striations on the cheek of this face are layered deposits left by the previous tide.

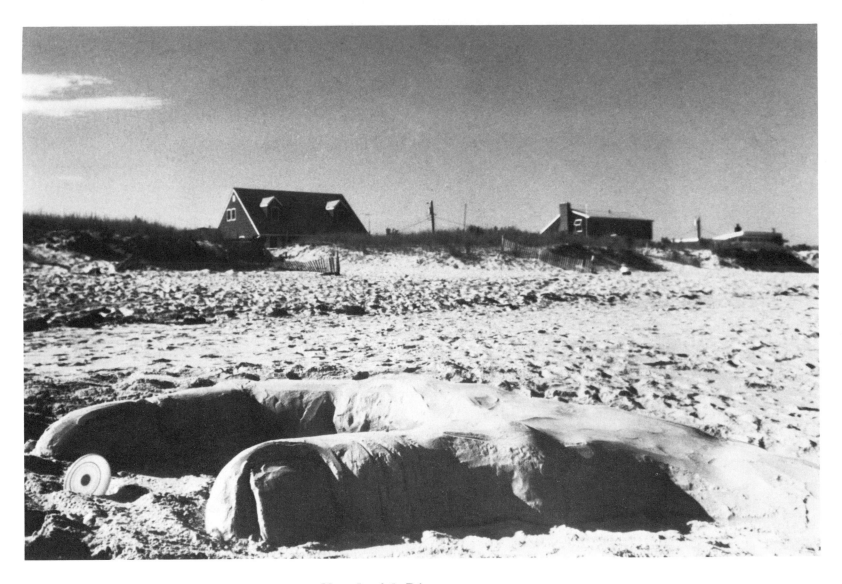

Hand with Disc *20x11x1-1/2'*

A giant, half-buried hand reaches for my disc which was planted nearby as a size reference.

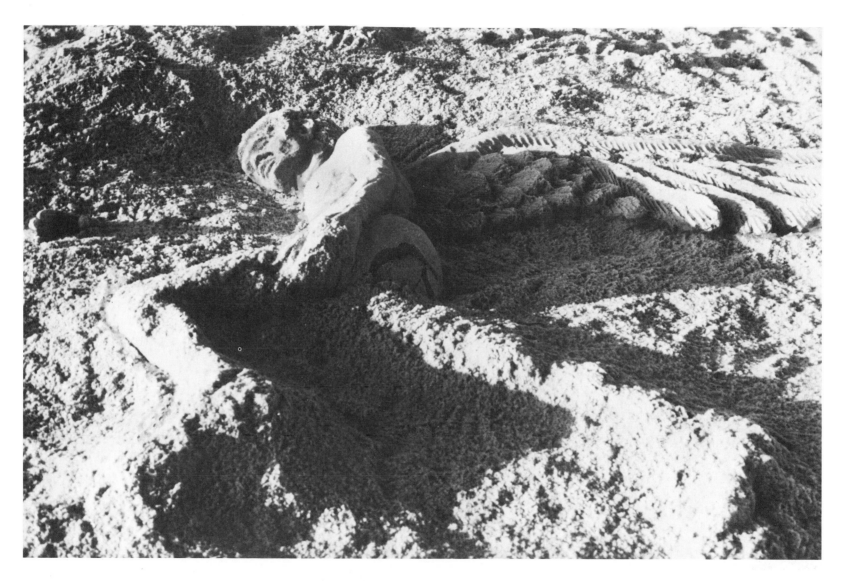

Fallen Angel *6x6x1-1/2'*

A low-relief study of the wing and of the small details in the face.

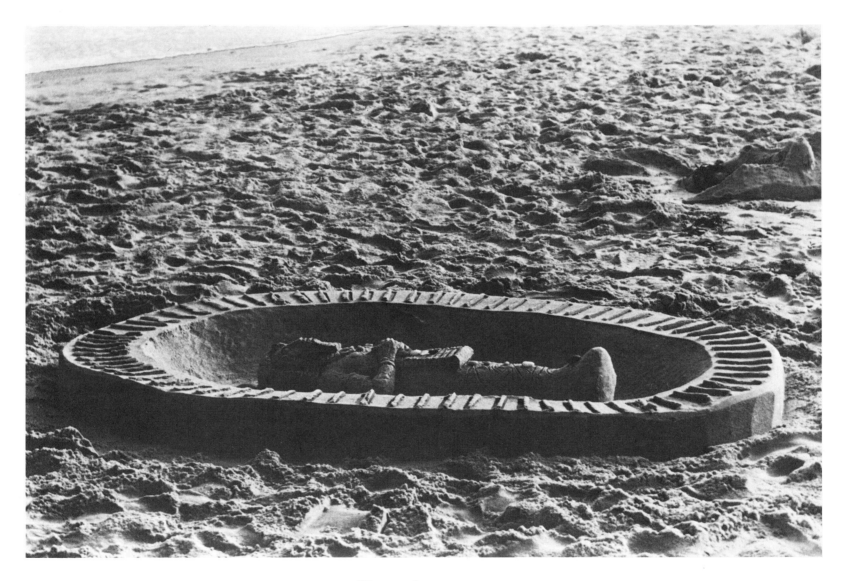

Pharaoh *4x2-1/2x1'*

This boy-king is the smallest piece represented in the book.
The wall evolved naturally as a result of pushing aside unneeded material.

14

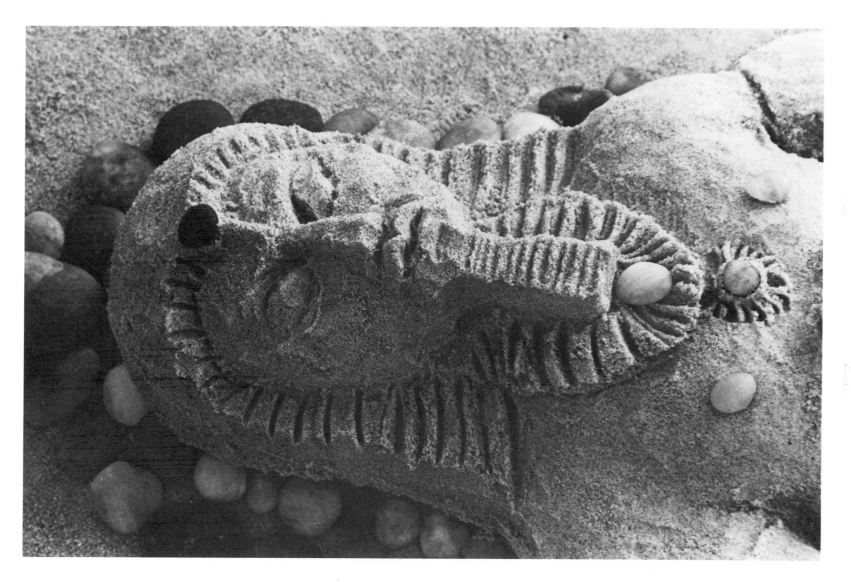

Pharaoh *detail*

The edge of a broken shell was used to carve these minute details.
Stones around the base of the head heighten the contrast between figure and background.

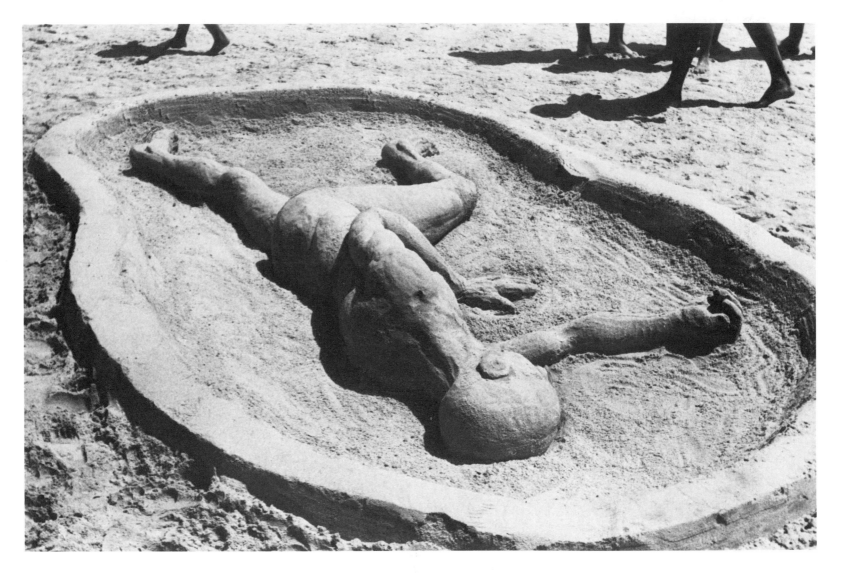

Bald Male Figure *6x9x1-1/2'*

Design is often a result of sand's constant need for support.
In this case, the left arm rests on the chest.

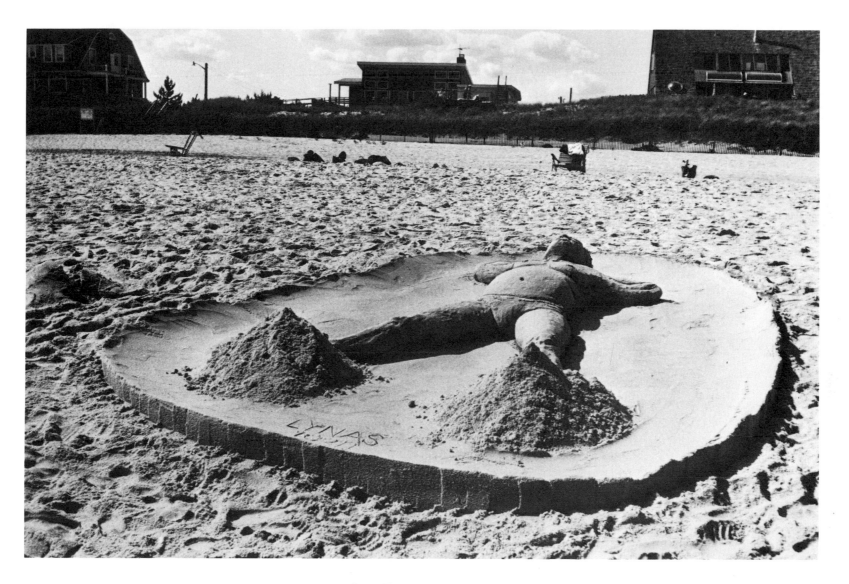

Sun Bather *10x7x2'*

*This relaxed, outstretched figure seemed to invite
the playful touch of burying his feet in loosely piled sand.*

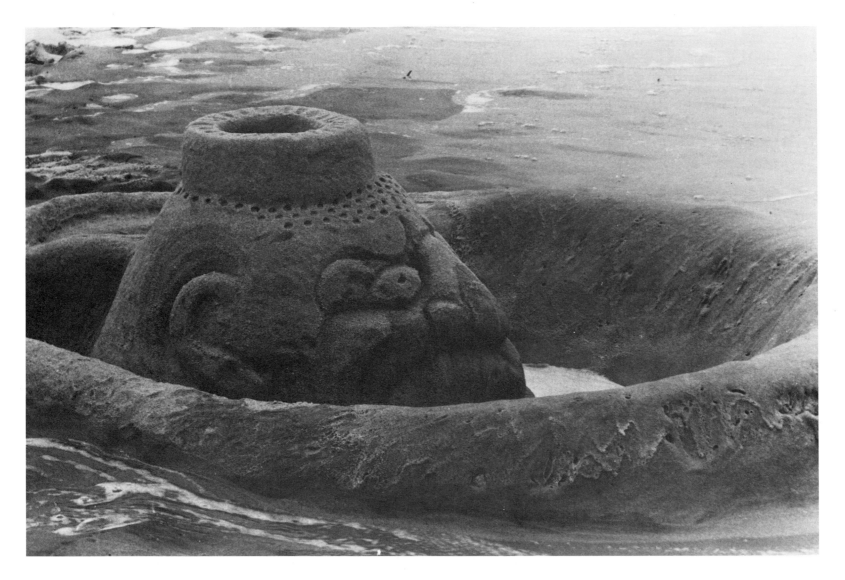

Afro Urn Head 7x7x4-1/2'

A race with the tide left the piece unfinished.
The comical face became two-toned when a wave surged over the wall.

18

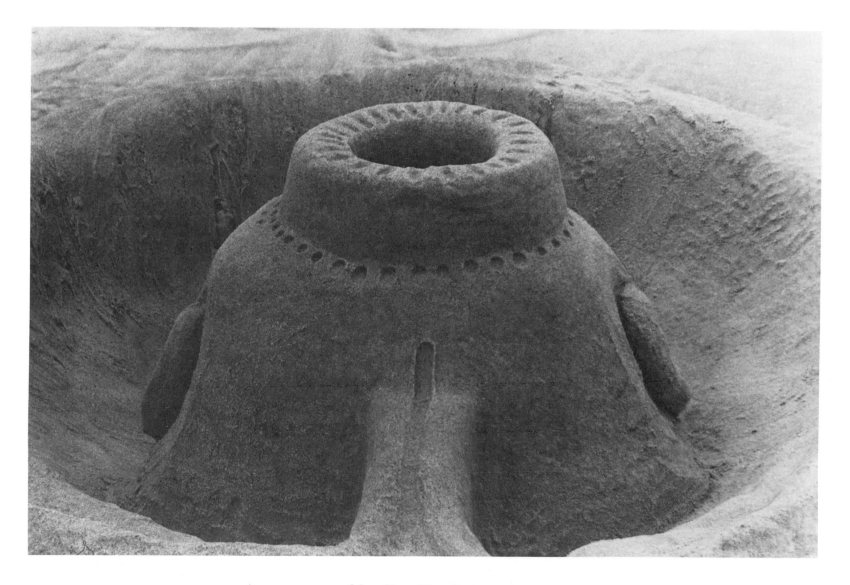

Afro Urn Head *detail*

A buttress at the base of the head assured extra stability . . . and a few more minutes of life.

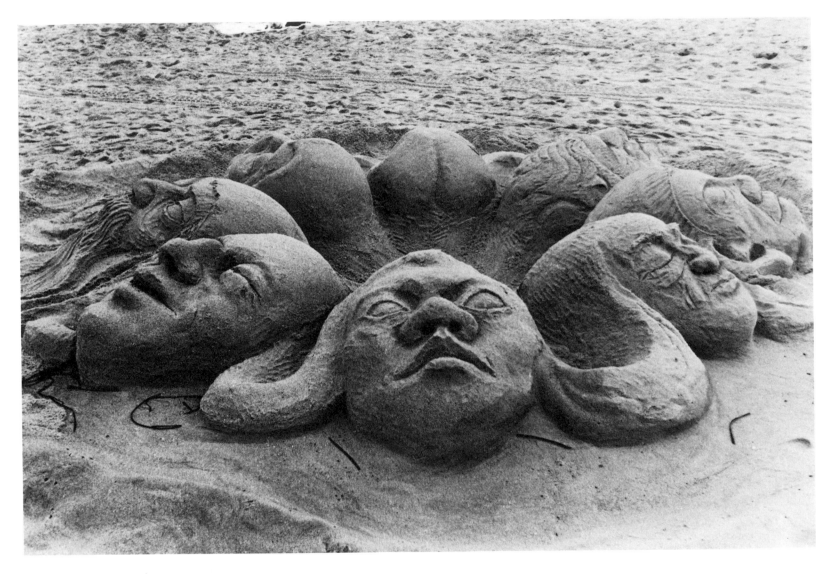

Eight Faces *8' diameter*

Modeled more than carved, these personalities were a study in facial variety.
A fire in the center would cast a starburst of light on the beach.

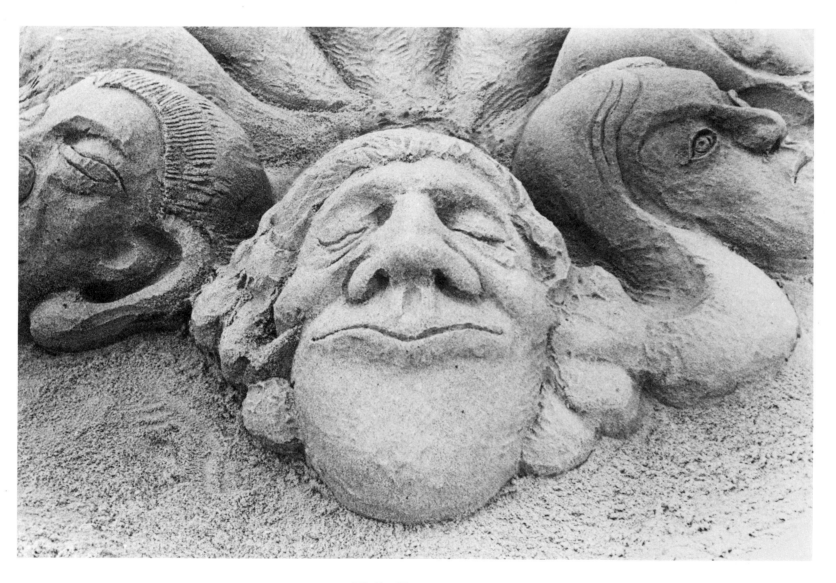

Eight Faces *detail*

In contrast to his serene neighbors, this man is a cartoon of propriety.

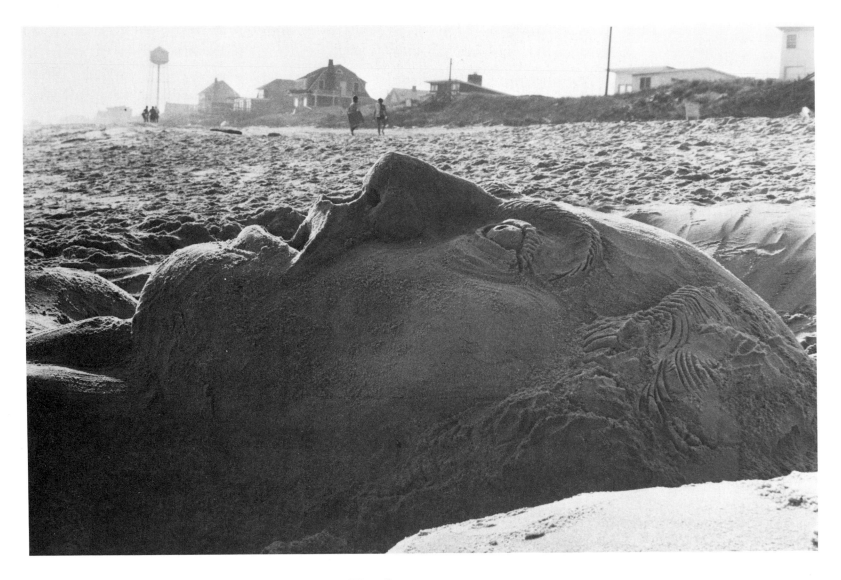

The Gasp *4x3-1/2x3'*

*Achieving the height of the nose was the engineering task here.
A disc, which can be bent to form tighter curves, imprinted the hair texture.*

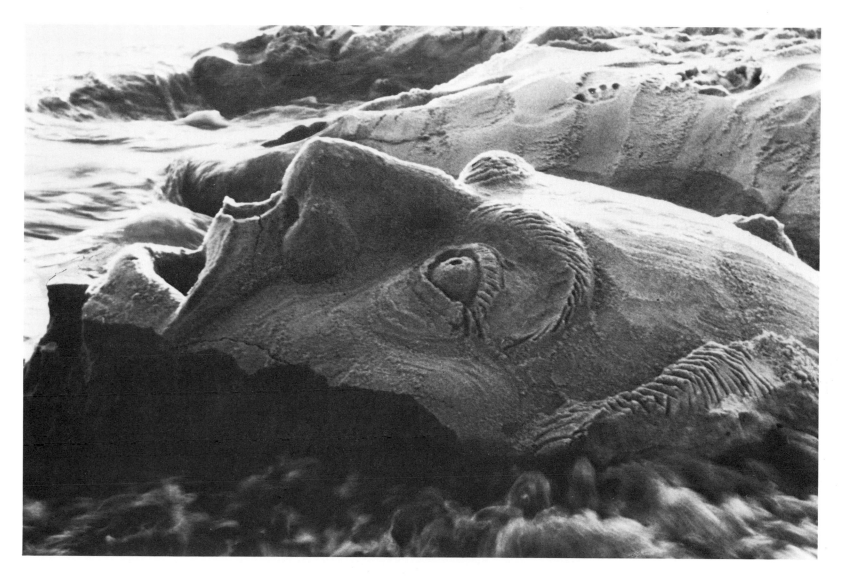

The Gasp *evolution*

*This is a good illustration of the sea's "instant antiquation";
in a few minutes the sculpture has aged centuries.*

23

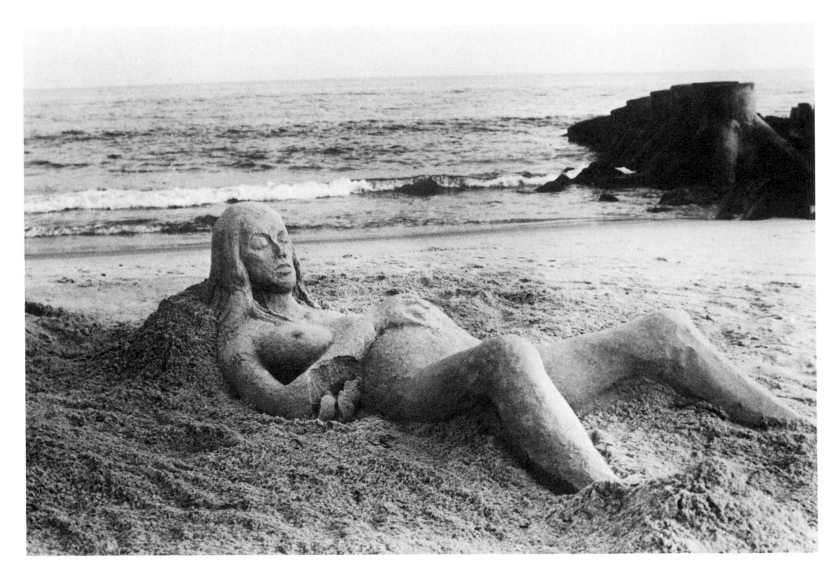

Pregnant Woman *8x3x3'*

*A half-hour figure study in soft shapes where much of
the time was spent devising support systems for head and legs.*

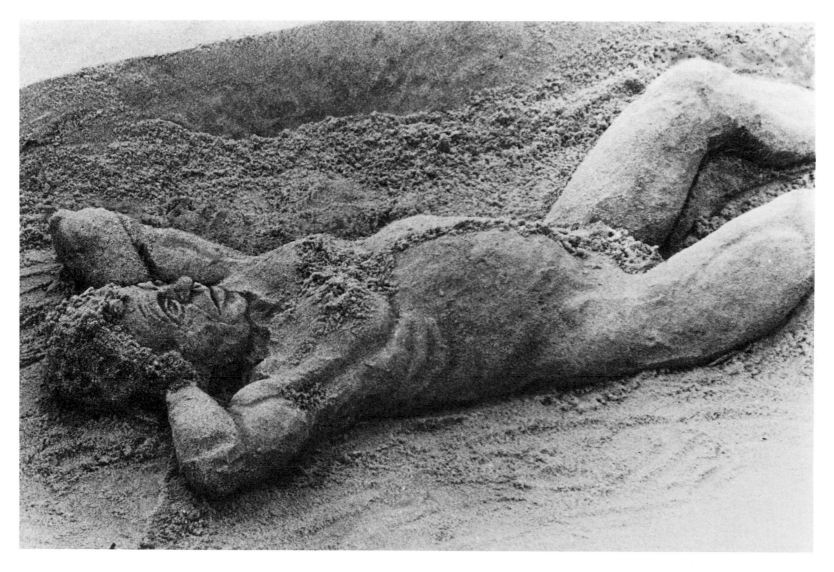

Hairy Little Man *4' long*

Sprinkling dry sand along the relatively smooth body surface created the hair.

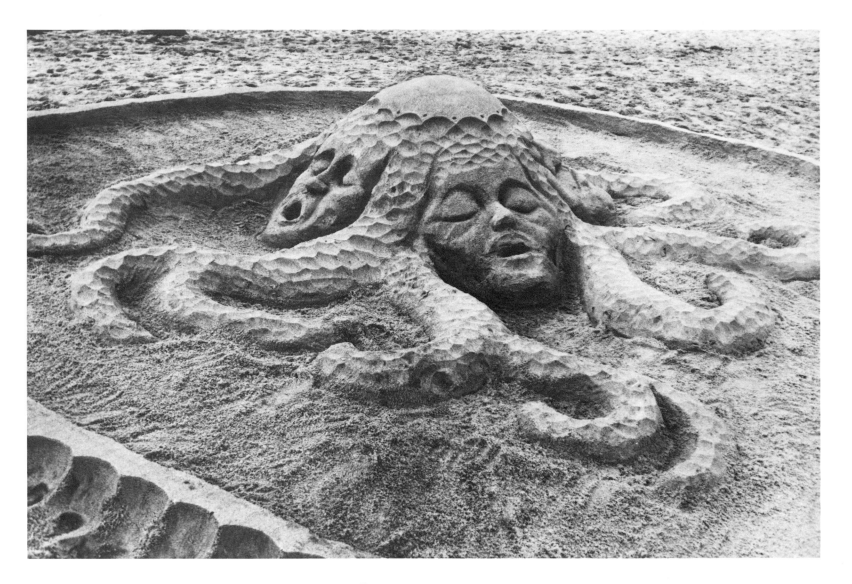

Octopus *18' diameter*

Different textures add to sculptural interest.
Here, a disc has scalloped the undulating tentacles.

26

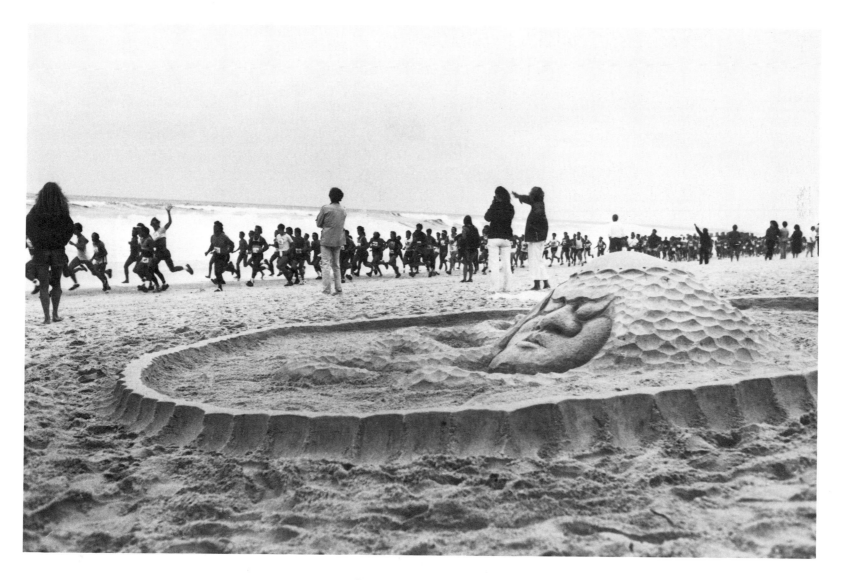

Octopus *new view*

*Five hundred runners passed this sculpture during
the annual Fire Island Sandpiper Race.*

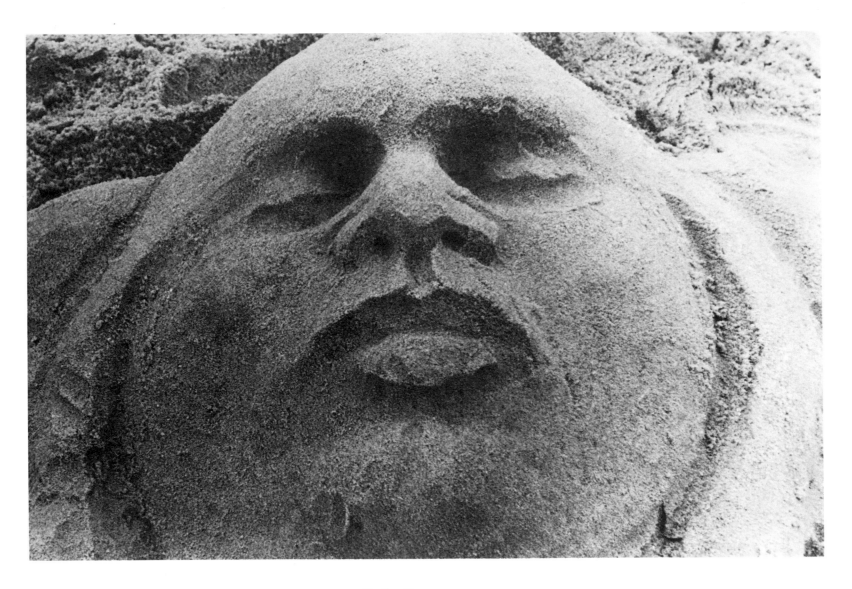

Solo Face *15" tall*

It took thirty seconds for this face to emerge from some loosely piled sand.

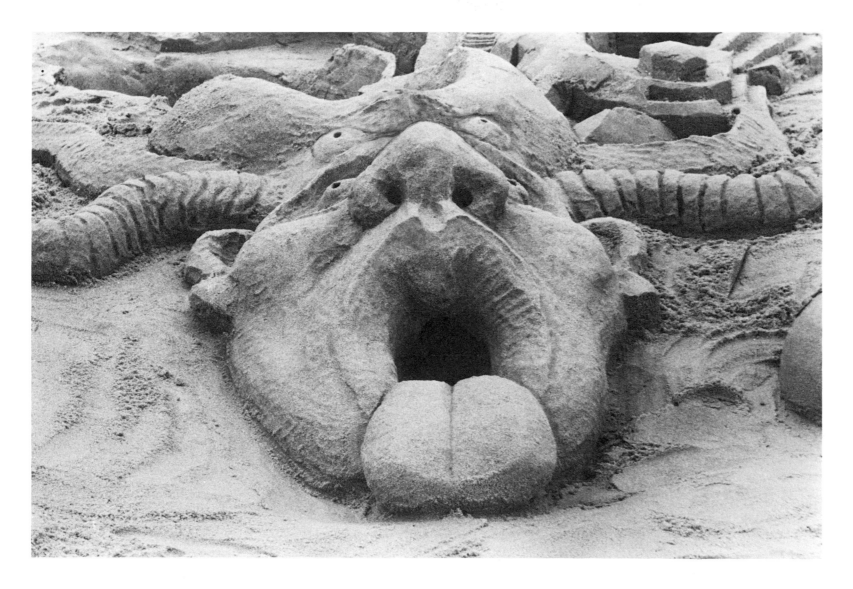

Devil Ram *3x4x1'*

This creature was made as a decorative entrance to a young friend's beach city.

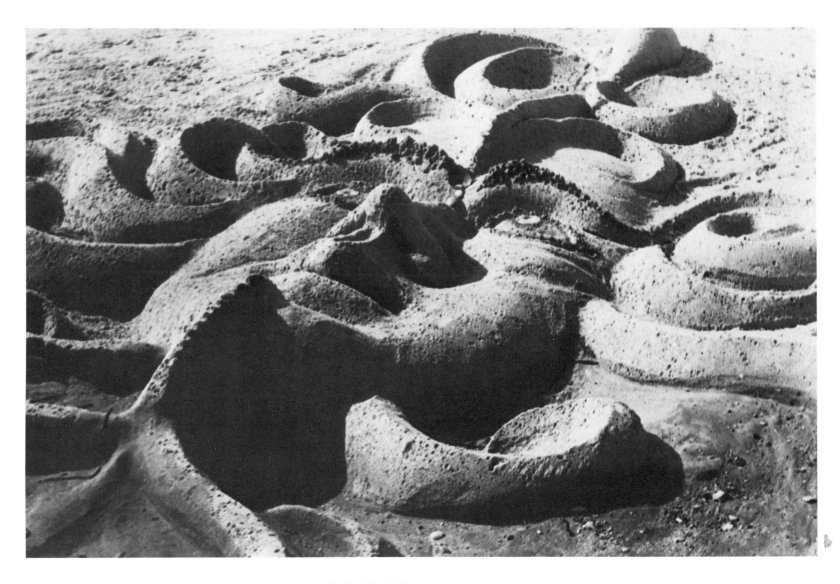

Jellyfish Eyes *15x12x1-1/2'*

This low relief sketch was designed primarily to interact with the incoming tide.

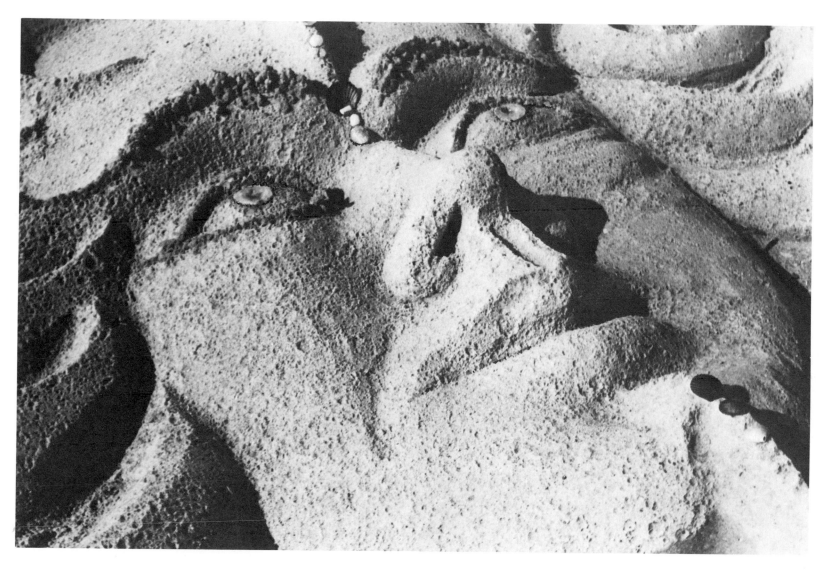

Jellyfish Eyes *detail*

Water was splashed on the face to erase hand marks and to stipple the surfaces.

31

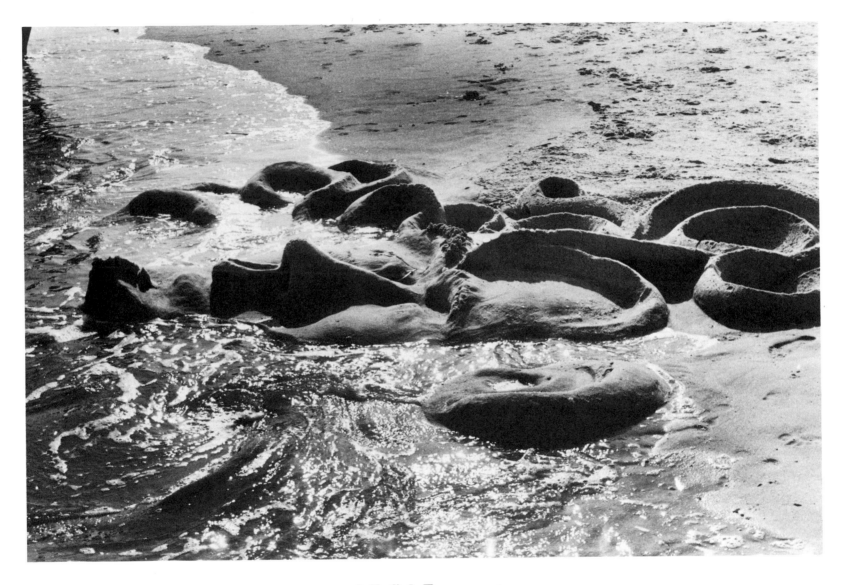

Jellyfish Eyes *detail*

Partially inundated by the waves, the lady is all swirls and gentle mounds.

Major Works

If I have the luxury to spend an entire day at the beach, at some point early in the morning I'll probably think about doing a serious piece of sand sculpture. Though occasionally I "just happen" to start a major undertaking, most large works need some pre-planning because I have to take along the necessary tools. To stay unencumbered, my selection is limited to a short-handled shovel, a bag of small spatulas, and, of course, some discs for sculpting and playing. Sometimes I take camera equipment with me, but usually I tend to leave all that behind since elaborate preparations set me up for failure by creating the tense expectation of success. I usually feel more creative when I rely on my body and the disc as the only tools I take to the beach. The ocean provides everything else.

Sand sculpturing is almost always a public performance and is therefore quite different from solitary studio work where one proceeds more slowly and methodically, free from the demands of an ever-changing audience. The beach sculptor has to be prepared to meet that audience, milling about, commenting, asking questions, moving on or staying to watch for hours. If I have readied myself, like a good actor, I can respond to the audience without being distracted by them and foregoing concentration (an essential when dealing with so unstable a medium as sand).

These massive sculptures are about ninety percent hard labor; you must be physically prepared for that. The stamina they require can only be maintained by a well-conditioned body. The constant stress on the lower back muscles alone is enough to cause serious problems or possible injury. The day-after stiffness sometimes makes me think of yesterday's sculpture as my last, until my fascination with the work takes over again.

Although I have refined a few techniques and am constantly experimenting with new ones, successful sand sculpting is not just a matter of "how-to's." I don't calculate like a physicist. Good powers of observation and an ability to retain the memory of visual images are actually more important than technique, which can be learned or developed from scratch by almost anyone. Through practice you will soon learn the physical limitations of the sand and perhaps your own as well. It is through practice, too, that you will learn to respond to the sand, to play the instruments of water, earth and gravity as if they were pieces of music forming in your hands.

As far as subject matter is concerned, there are no rules other than what your experience and imagination conjure. It would be more than I could hope for to create a sculpture with no reference to the known universe. As it is, each piece, however individual, takes its inspiration from nature. Working in representational forms — for example, figures with muscles and veins and teeth — puts many more demands on me than do simplified abstractions.

While I work on a large sculpture, I move around the piece, working on one area, then another, trying to stay aware of the whole. Like finding pictures in clouds, I look for suggestions made by various accidents; the forms "tell" me what to make. This two-way communication is spellbinding. Occasional breaks to answer questions from the audience help remind me to sun my face a bit, drink some water or stretch my legs. Ten minutes of vigorous disc play — suspending it on the constant ocean winds, then diving after it

as it sails into the surf — bring me to my earthly senses and I return to the sculpture enlivened. I may do this several times during the rest of the day, usually continuing to work until the first wave intrudes. The sculpture is "finished" only when the sea reclaims it.

Another day: your own sand song

Imagine you are going to make a sand sculpture. You are planning to build, by yourself, a substantial piece on a public beach. You will need the whole day so you get an early start.

The sun has just risen; the damp morning air is still quite chilly. You eat a nutritious, but light breakfast, and pack a few things for the beach: fruit, frozen water in a plastic quart bottle, a towel, your tools, and a couple of discs. You wear enough to keep off the chill and to protect you later in the day from the strong sun, and you set out.

Crossing the dunes, you survey the area to find that high tide has come and gone, perhaps an hour or so earlier. You have about ten hours before the water returns to approximately the same level, depending on local weather conditions that day. You head for a hillock just below the high tide line where the piece will have good visibility and stature. The water will likely reach there last, perhaps to form an island around your work. You grab a handful of sand; its texture is fine enough. If it contains too much sharp or abrasive material, a few hours' contact with your body will rub the skin raw. The presence of too much organic matter, such as seaweed and jellyfish, may cause a problem with flies, especially when you are covered with perspiration. You decide to stake the site here, planning a scale based on the immediate environment — dunes, jetties, pathways — and your own limitations of time and energy.

Moisture is the key to strength and stability, so you dig down for it. Taking from one area and piling on to an adjacent one creates the effect of doubling your progress; you are careful, however, to avoid making pits or unlevel ground which might make for uncomfortable working, or which could even be dangerous, particularly to little children who are likely to be nearby.

You quickly realize that rhythm in shoveling is crucial to maintaining energy and keeping up the pace, so you hum, or even sing aloud if the beach is still uncrowded. You may lift ten or more shovelsful per minute for up to five hours. Three hundred shovelsful at eight pounds per shovel could mean that you'll move more than a ton of wet sand a distance of about a thousand feet. Singing will save your body and soul. You feel a bead of perspiration clinging to the end of your nose and you count the shovelsful until it falls and is absorbed by the sand. The deeper you dig, the heavier each shovelful becomes.

Soon — in a matter of hours — you have built quite a large mound with a few crudely formed intimations of faces and figures. You plant the shovel in the now warm sand outside the area of the sculpture, hang your sweatshirt on the handle to mark your territory, drop to your knees, and begin studying the precise condition of the sand with your body. You brush away the dried surface sand as it will be unstable. On sunny days loosely piled sand loses moisture quickly, too, so the trick is compression. You sit on, hit, push, tamp the sand, doing anything you can to make the most densely packed form possible. You will be more concerned about carving and decorating after you have "conditioned" the raw material. A woman who has been watching for some time asks what you are making. You say you do not know. Being careful to avoid wasting motion, you use what you have wherever it has fallen, making a wall from the leftovers of a figure, a lion's head from the excess of a vase.

34

It's noon and you are exhausted. You dive into the ocean, floating, swimming, bathing away fatigue. Approaching your work from the water, you see that the compressed and disc-smoothed mounds are ready for embellishment. You have already experienced several slides and a major cave-in, so you have gone into the "delicate mode" where you feel as if the sound waves of a passing airplane might cause damage. Some kids have begun to make their own sculptures nearby.

As you make your first cuts into the smooth surface, you have to resist the temptation to merely draw on the exterior, and you dig deeply, searching for the three dimensional revelations within. You strongly sense people behind you, watching, perhaps judging, ready to walk away at any moment if you don't deliver. You supress those thoughts and the urge to look at them, and bury yourself in the search for the sculpture . . . one grain at a time.

At about six-thirty, as the sun gets lower by the moment, you are startled by the splash of cold water on your legs. The dissolution begins. Though you may have worked virtually non-stop all day, you forget that you're bone weary. It is dusk, the sky has gone pink and purple and a coppery shaft of light angles up from the horizon. Shadows are long. You stop and become another onlooker. A starfish washes over a wall and sinks to the bottom of a swirling pool; a ring of foam settles on the shoulders of a sleeping human form. An arm goes. A city is washed away. The demise, casting its disappearing contours across the sand, is gradual, haphazard, sometimes violent, always surprising and fresh. You are reminded that everything is change, that it is the natural order of things.

You pack your tools and head for home, turning once to catch a last glimpse of the sea.

New York City 1983

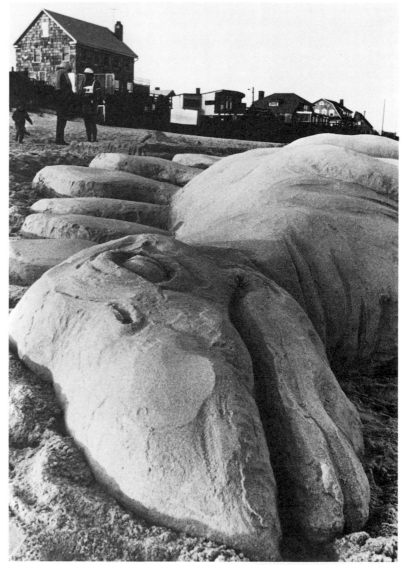

Stegosaurus *detail*
This life-size dinosaur required six hours of digging and five hours of sculpting. The head has just been repaired after a dog ran through it.

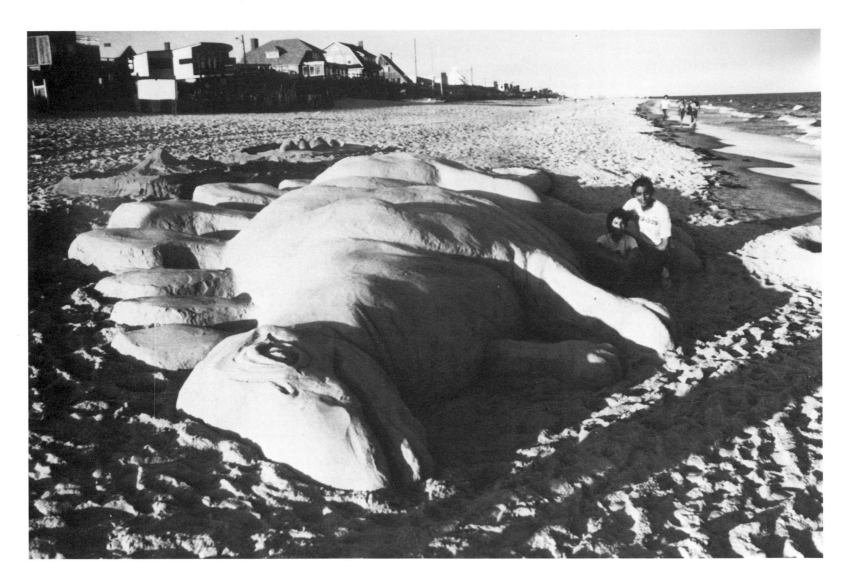

Stegosaurus *38x12x5'*

*Pre-planned as a commissioned event for the Ocean Beach Arts Council
of Fire Island, the creature has about an hour before the tide arrives.*

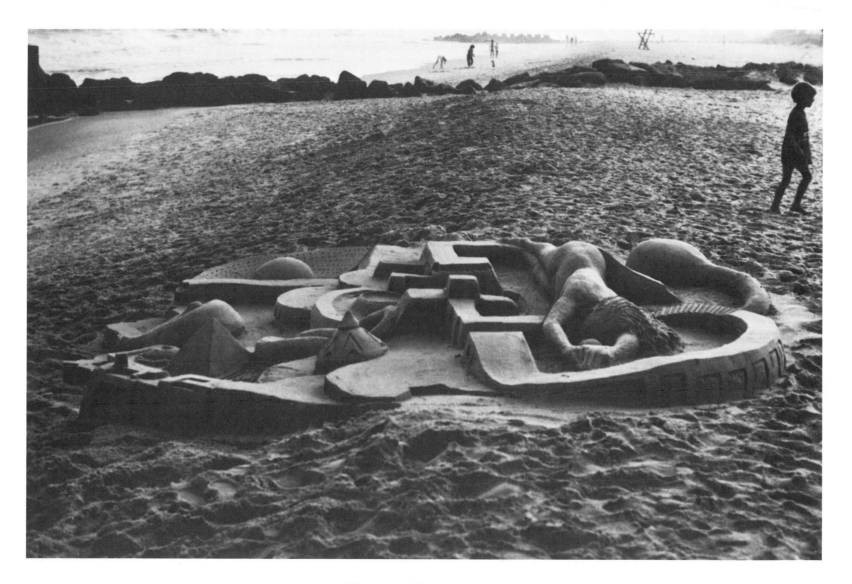

Woman City *10x11x3'*

*A tribute to human fertility combines a serious figure study
with humorous architectural fantasies.*

37

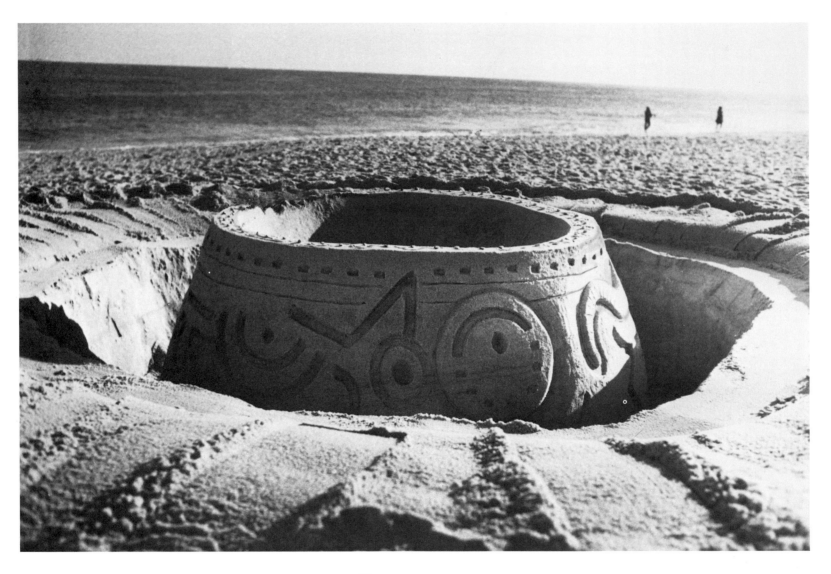

Vase 8' diameter

A scrap of dune fence provided the tool for cutting the surface decorations.

38

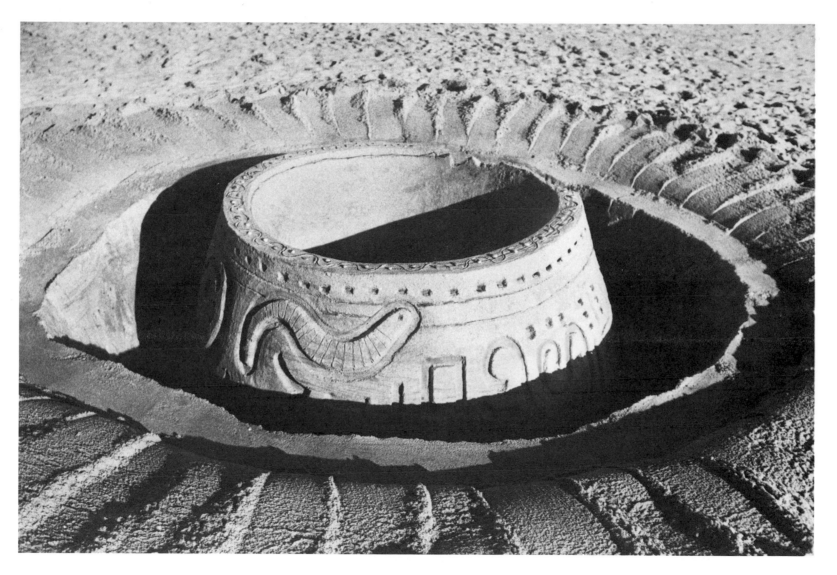

Vase *new view*

Dehydration caused the rim damage. The bottom of the vase was invisible to observers who were unable to get close enough without stepping into the four-foot-deep moat.

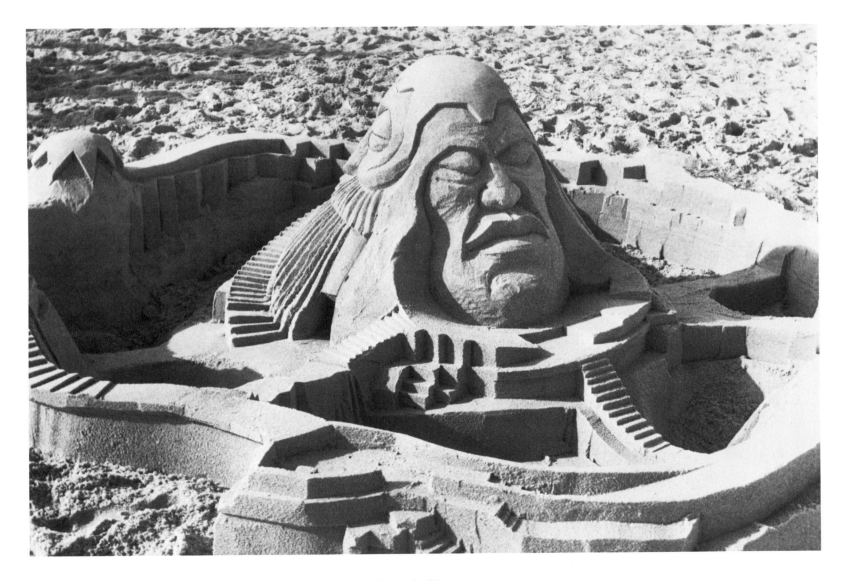

Two-Faced City *10x12x4'*

This sculpture grew as if out of control from a simple mound into a small city.

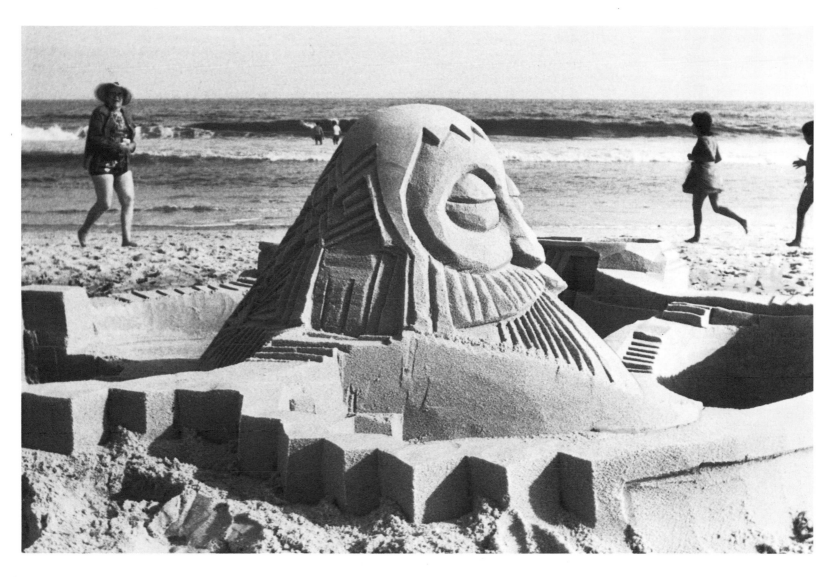

Two-Faced City *new view*

*Mixing rigid architectural structures with more organic forms
creates textural variety and strong play of light and dark.*

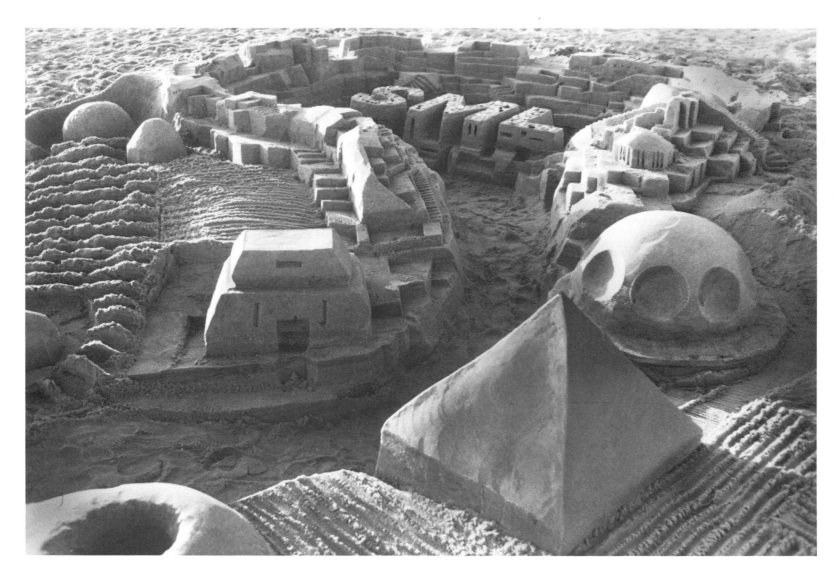

SML *25x15x3'*

*For my daughter Sarah's birthday present, a disappearing city based
on her initials with a natural "green" environment of trees and farmland nearby.*

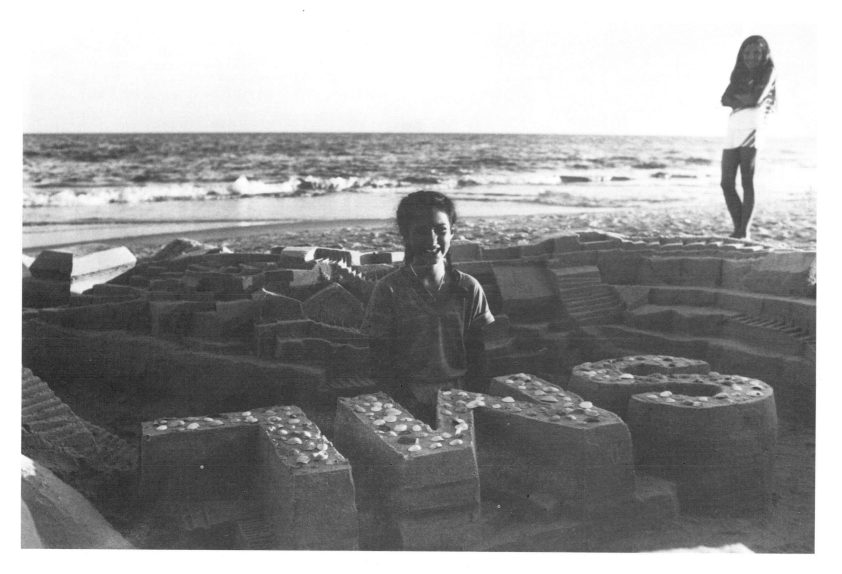

SML *detail*

Throughout the afternoon, passersby gathered small shells to decorate the birthday gift.
The top surface of the letters was the original level of the beach that morning.

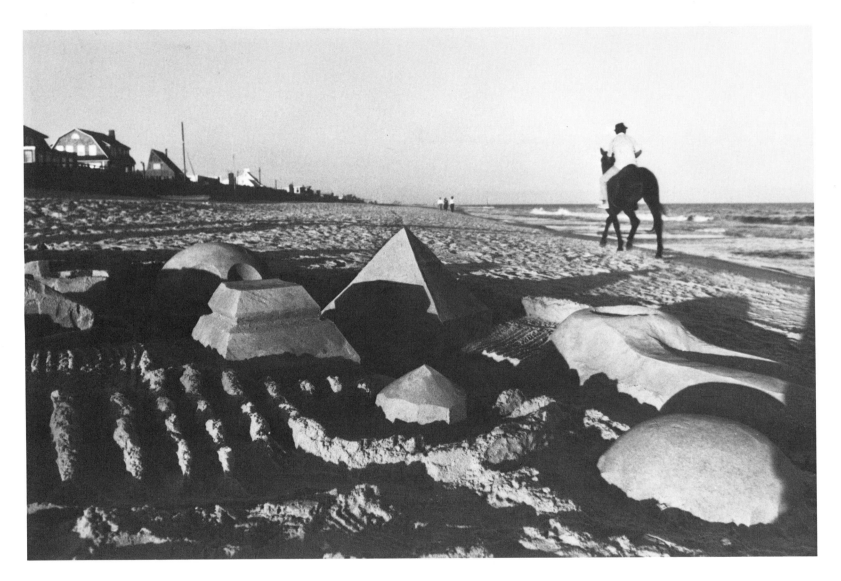

SML *detail*

A horseman rides past some unfamiliar Fire Island architecture.
Long shadows exaggerate the sharp edges and add contrast as the sun goes down.

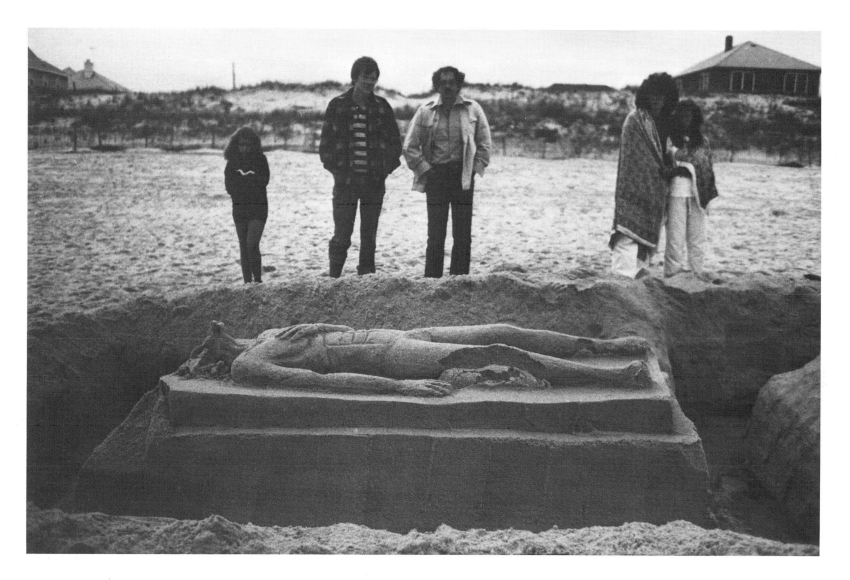

Sarcophagus *10x5x4'*

*A channel fed the tide into the moat where water action at the base of the bier
caused the human face to collapse, leaving what looked like the profile of an animal.*

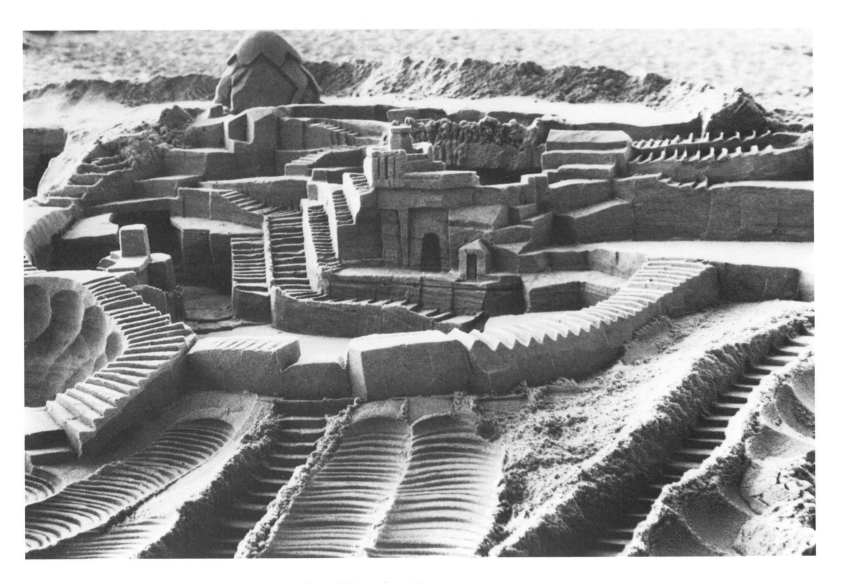

Rambling Architecture *20x12x4'*

*The natural slope of a beach at water's edge provides densely packed, moist sand,
excellent for carving strong vertical planes and deep undercuts.*

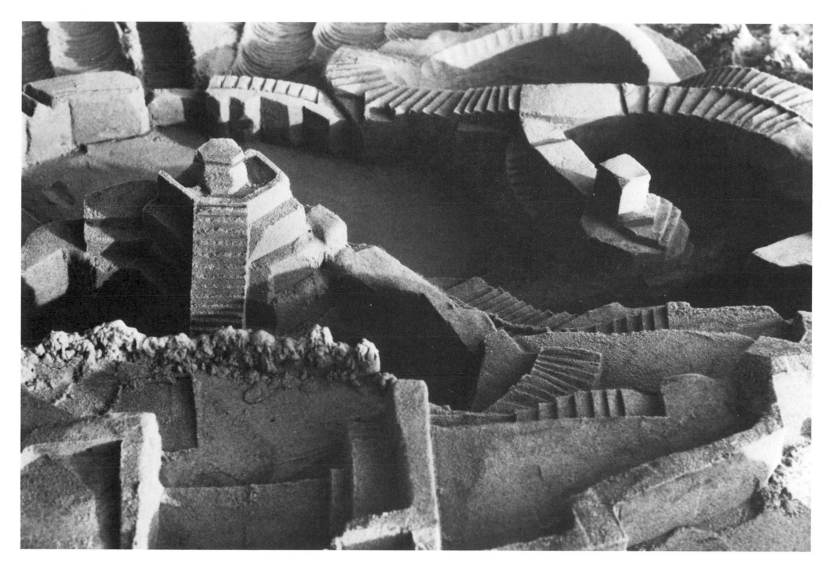

Rambling Architecture *detail*

Walls go off in all directions, while multifaceted and angled forms play with the moving light.

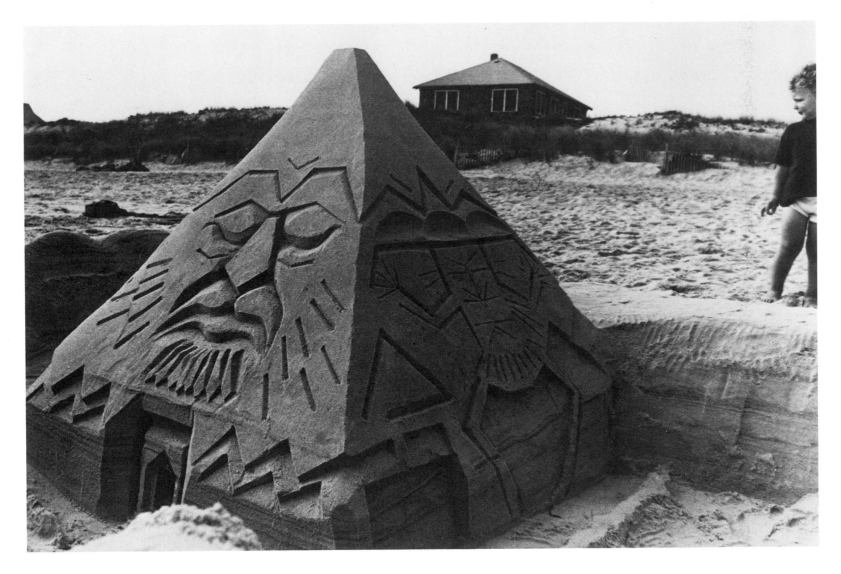

Pyramid *4x4x5'*

"Can you make something to cause the sun to come out?"
was the question which prompted this construction. Each side bears a solar design.

48

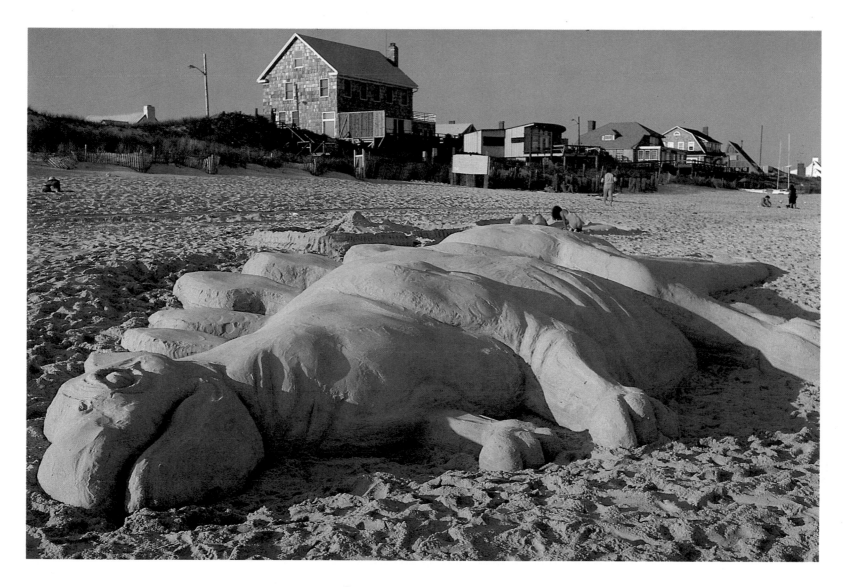

Stegosaurus *38x12x5'*

Large sculptures magnetize other artists.
The little girl worked intently on her own piece well into dusk.

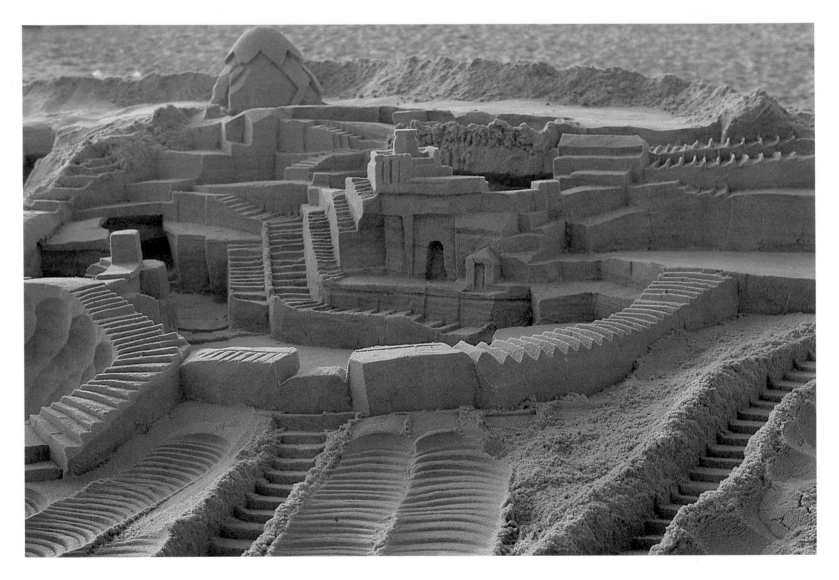

Rambling Architecture *20x12x4'*

In the early evening light, the architecture takes on a hushed, almost religious quality.

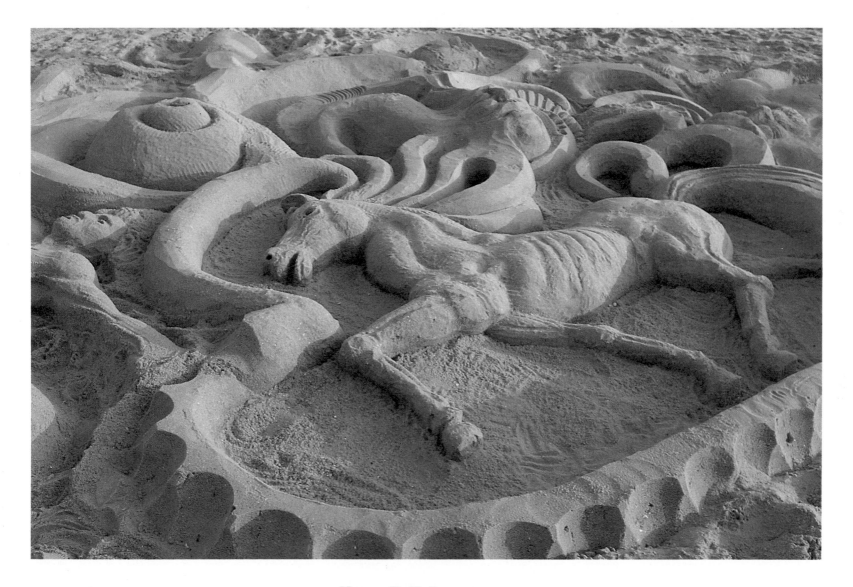

Horse Relief *15x15x1-1/2'*

*Free association produced this low-to-the-ground sculpture
with figures, animals, faces and swirling connections.*

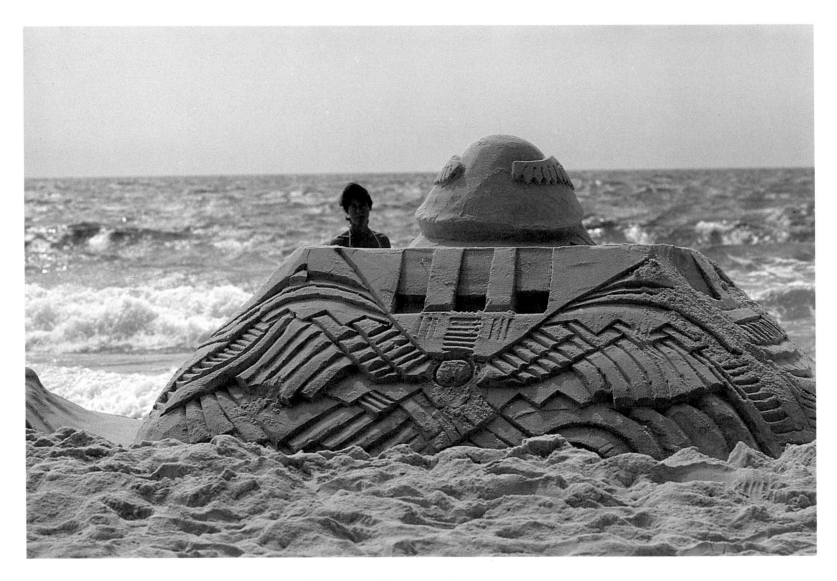

Throne of Mercury *detail: rear view*

*Lacking a moat or other protective construction, the sculpture
was easy prey to vandalism. Note damage on right side and center.*

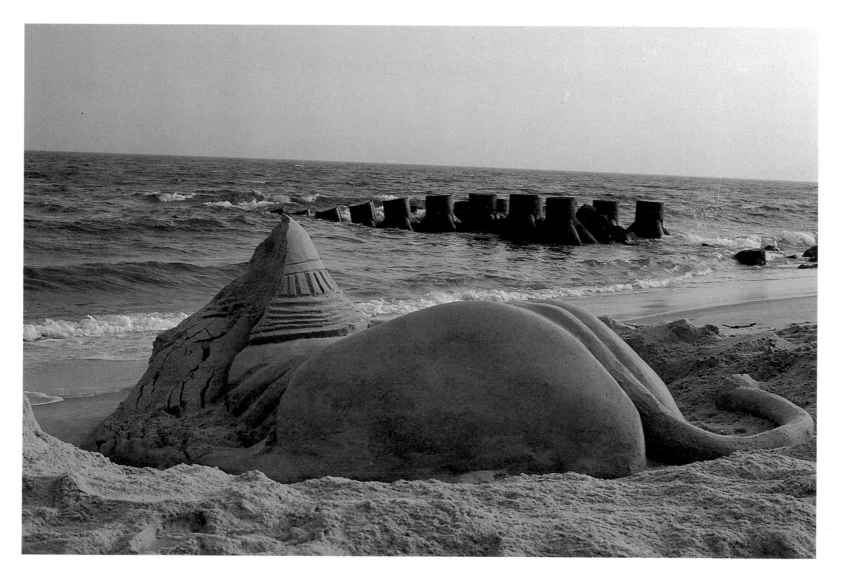

Sphinx *14x7x5'*

Steep angles and dehydration caused the partial collapse of the head.
Eventually, the water completely submerged only the front part, leaving the muscular rear flanks intact.

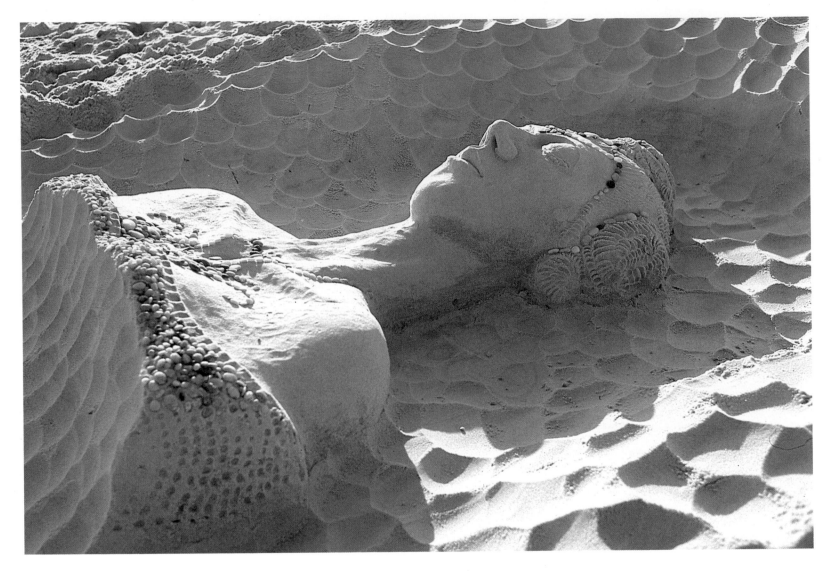

Dutch Lady *6x4x2'*

*This photo and its companion on the facing page — taken roughly 90 minutes apart —
vividly demonstrate the visual impact of the passage of time.*

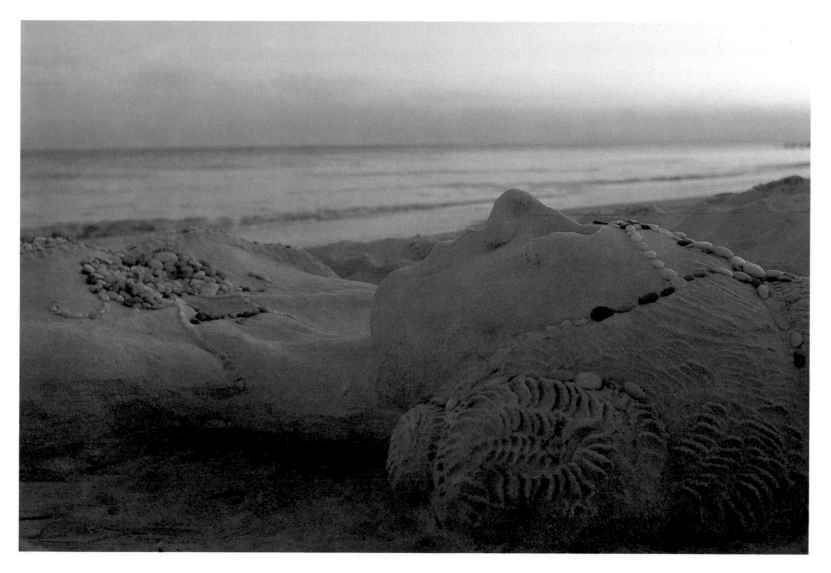

Dutch Lady detail

The effects of the intruding waves are barely visible in the foreground as the sun rapidly disappears.
I squeezed the sand between my fingers to create the hair texture.

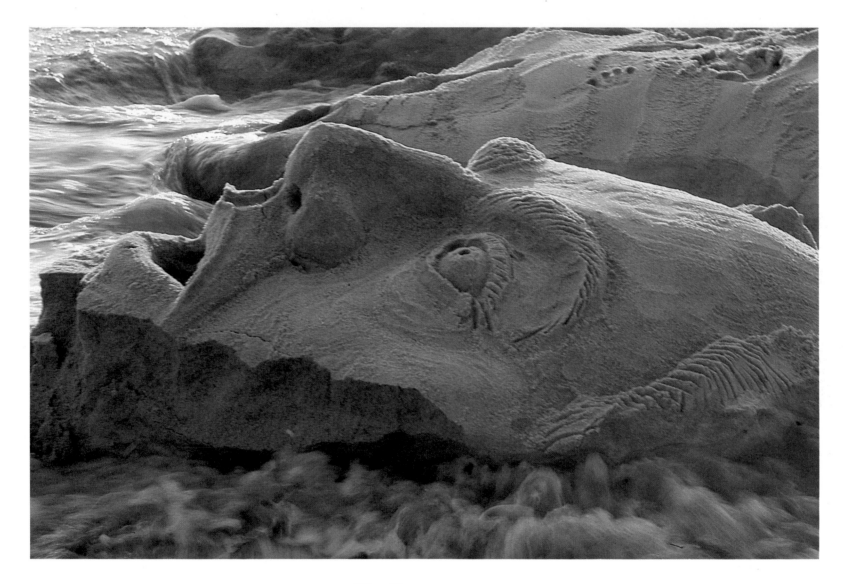

The Gasp *4x3-1/2x3'*

*Because of the violent action of the water around the face,
we are likely to interpret the man's expression as fear.*

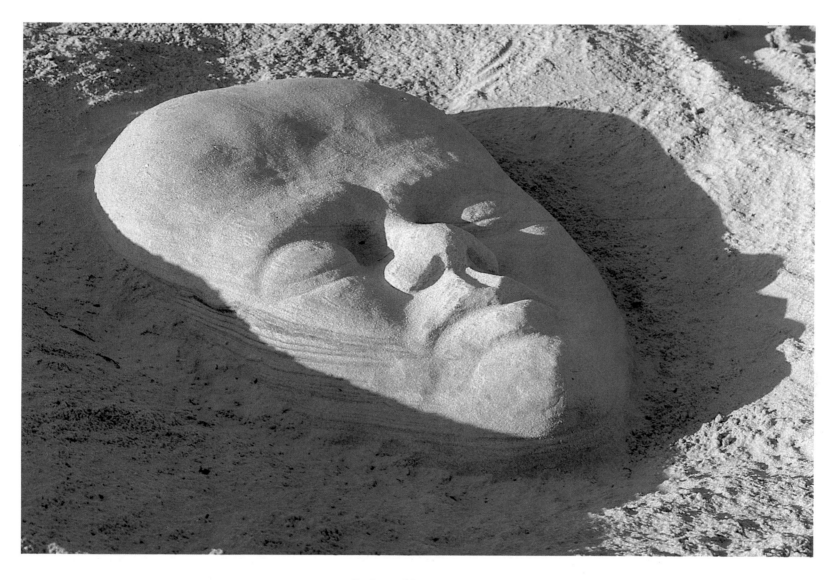

Infant Head *5x4x2*

High winds have blown away the sun-dried sand to smooth the skin of this piece.

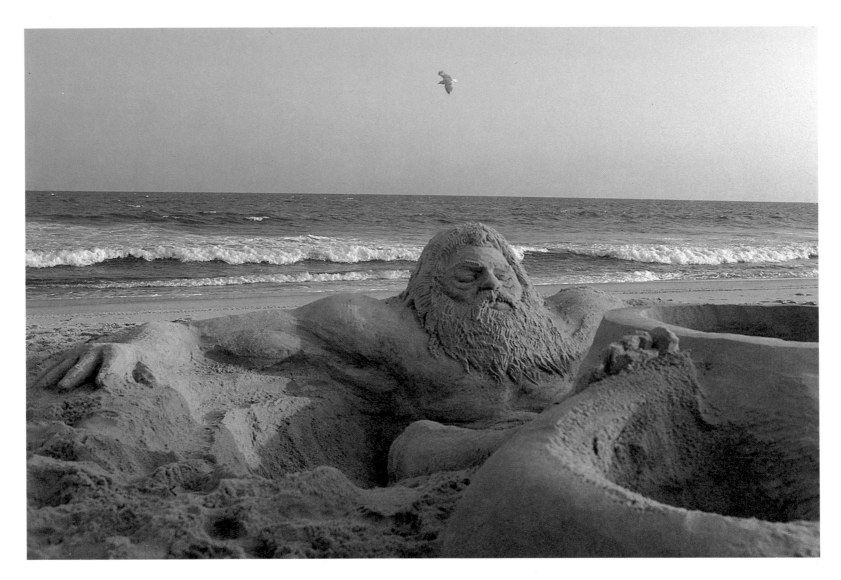

Man with Vase *detail*

The pit supports the large proportions of the figure and provides moist sand from the water table.
Beards are convenient devices for holding up heads.

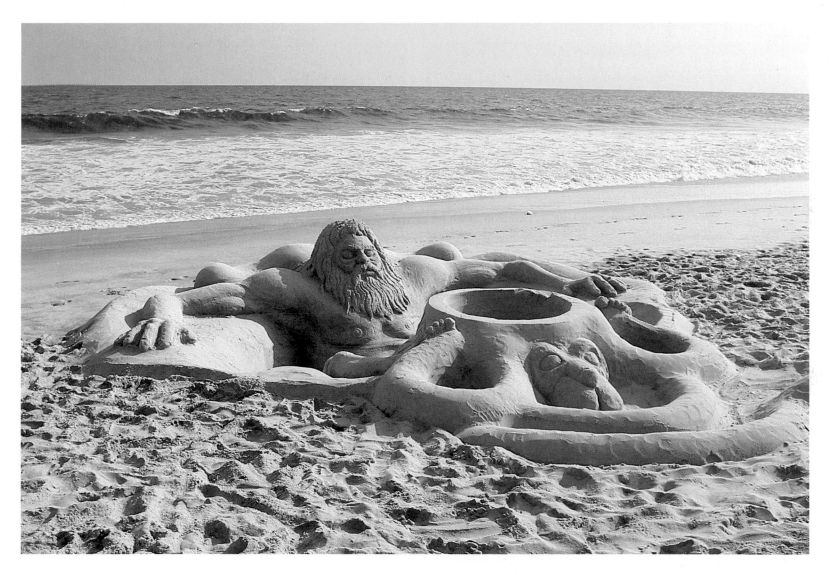

Man with Vase *15x20x6'*

*Note the damaged rim of the vase. This was essentially irreparable
due to the delicacy of the wall, especially after surface embellishment.*

Fallen Angel *6x6x1-1/2'*

Pouring loose sand close to more refined areas creates suggestions of anatomy.

Sand Day '82 *detail*

When an audience crowds in, concentration is more difficult.

Jamie Hankin

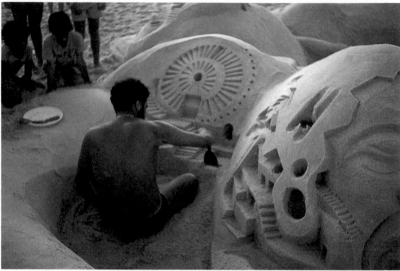

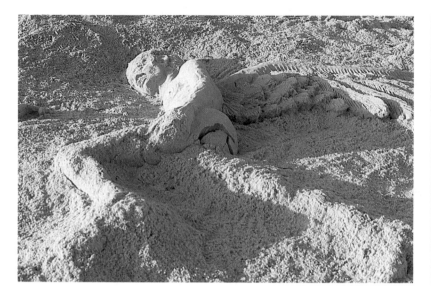

Ines Jimenez

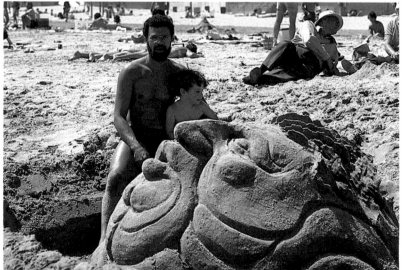

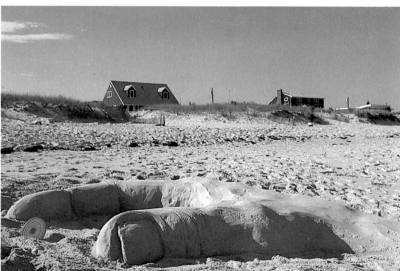

Santa Cruz Head *4x4x3'*

The silty sand in northern California made a sturdy piece for my nephew.

Hand with Disc *20x11x1-1/2'*

Here I jokingly made the sculpture play my favorite sport.

Giant *35x25x5'*

*The head is sharply defined, but the chest
is merely suggested by smoothing broad areas.*

Giant *detail*

Churning waves have filled in the area around the face.

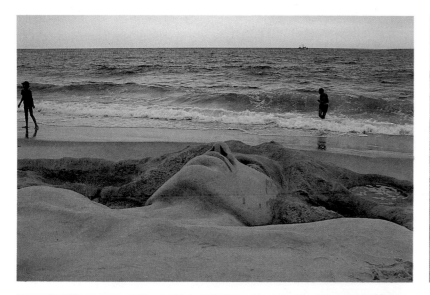

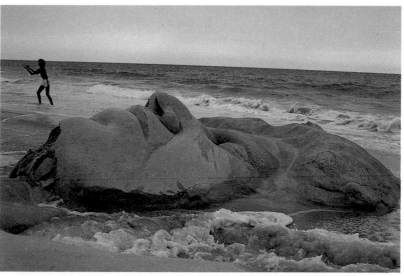

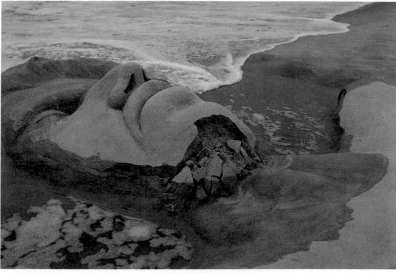

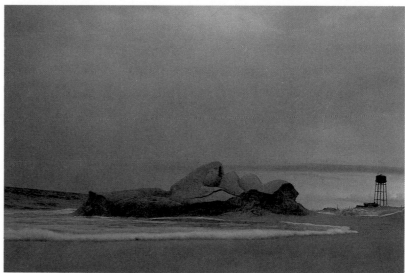

Giant *detail*

*Radical alterations are welcome after hours
of anticipation.*

Giant *detail*

*Would you know that these remnants had been
a human face?*

61

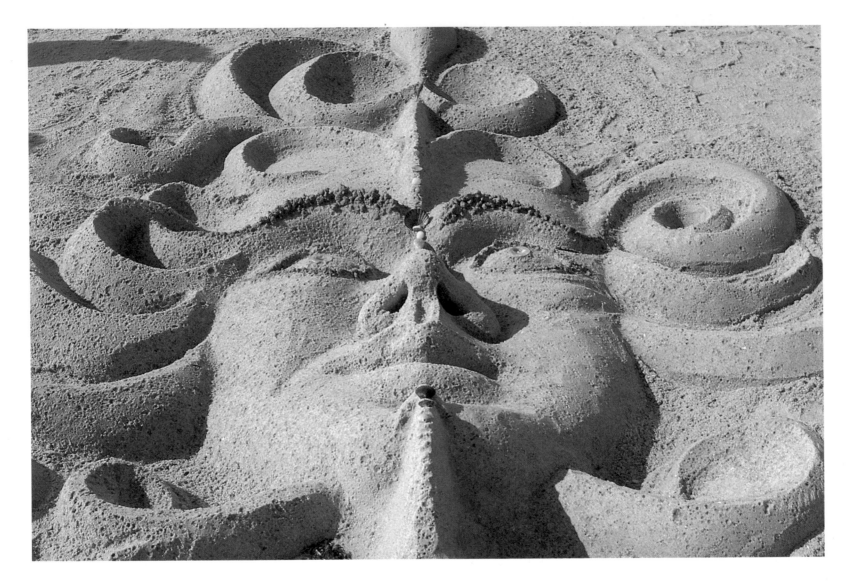

Jellyfish Eyes *15x12x1-1/2'*

*Working in low relief usually means covering broad areas quickly,
in this case, just in time to experiment with water movements around the swirling forms.*

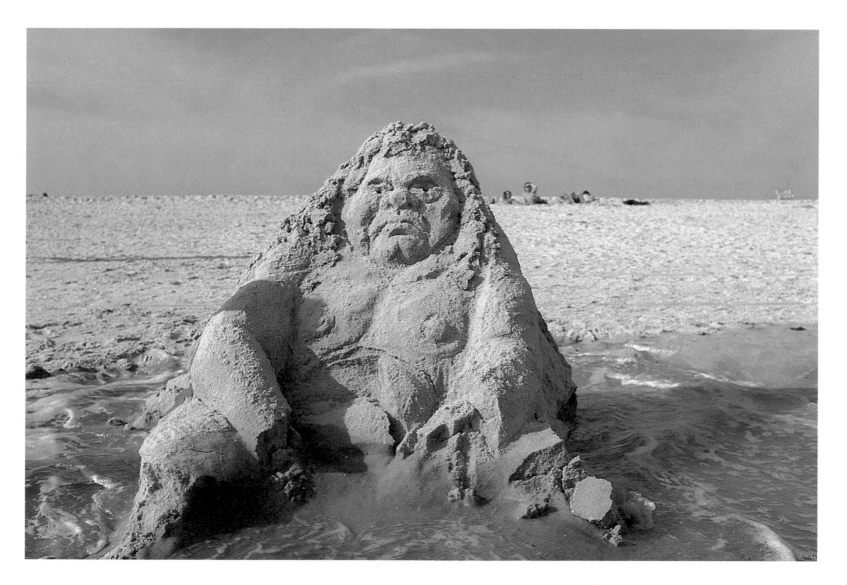

Buddah *4x5x5'*

*Once the waves have made their initial alterations,
the sculpture softens in graceful connection to the earth.*

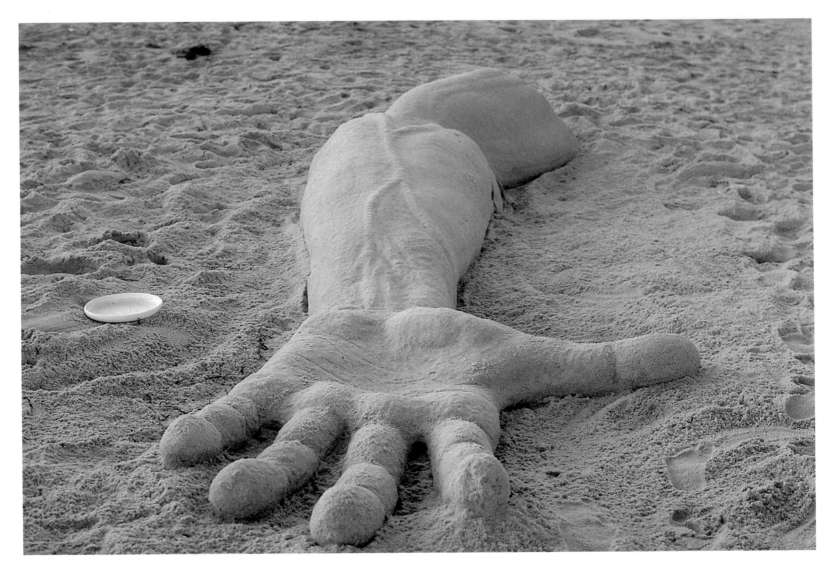

Arm and Hand *22x5x3'*

This truncated arm looks as if it had fallen from the body of a colossal statue.

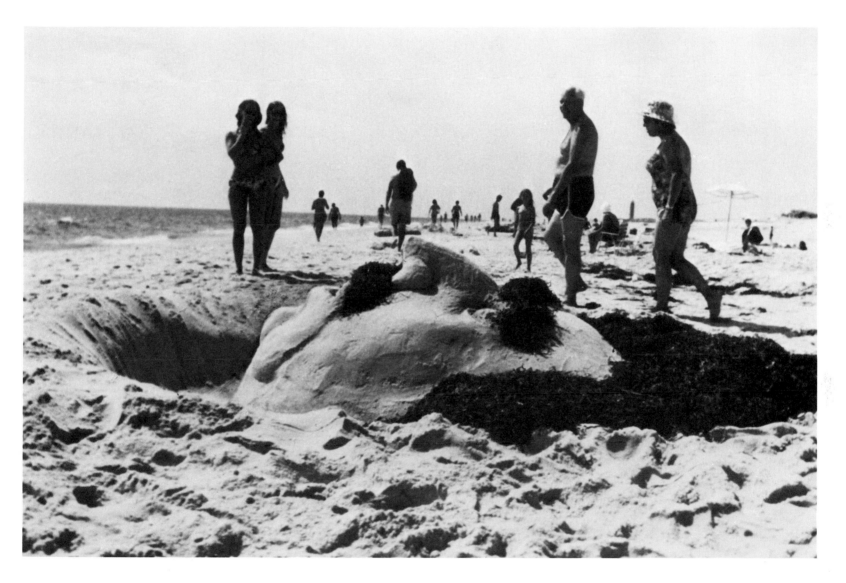

Face with Seaweed *13x9x4'*

The organic matter in seaweed attracts flies so we couldn't stay too close to this one.

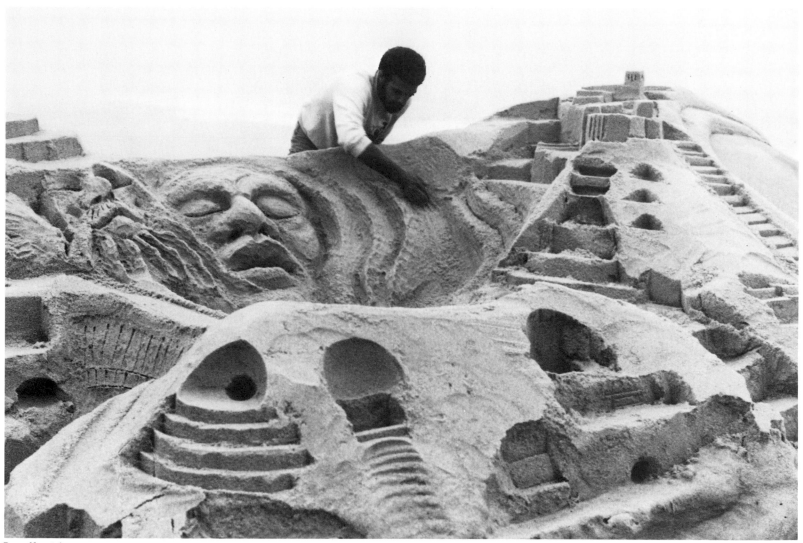

Peter Kornicker

Sandsong *detail*

The featured work in our documentary film of the same title,
this portion is behind the head pictured on the next page. (Note sand tower in both photos.)

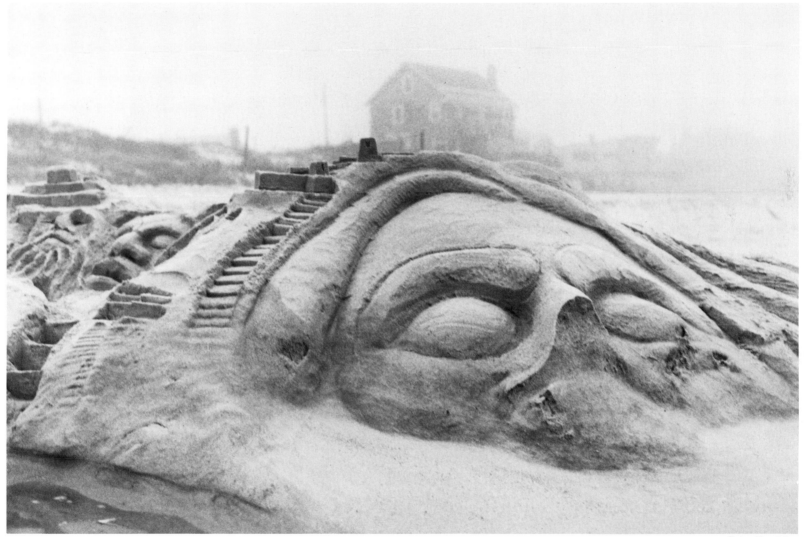

Sandsong *detail*

These are the remains of a face which used to dominate the sculpture.
An hour before the photo was taken, the head measured nine feet from chin to crown.

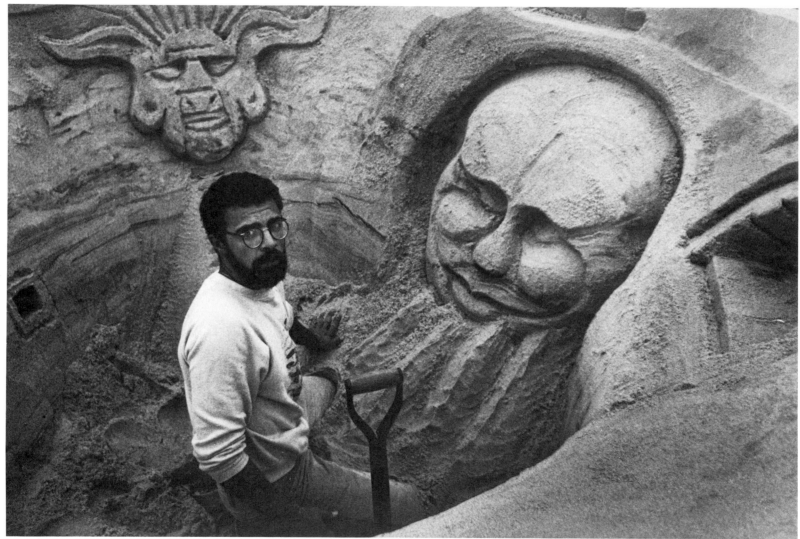

Stuart Goldman

Sandsong _detail_

An interior section of the piece shows early stages of construction.
This sunken room protected me from November wind and sea spray.

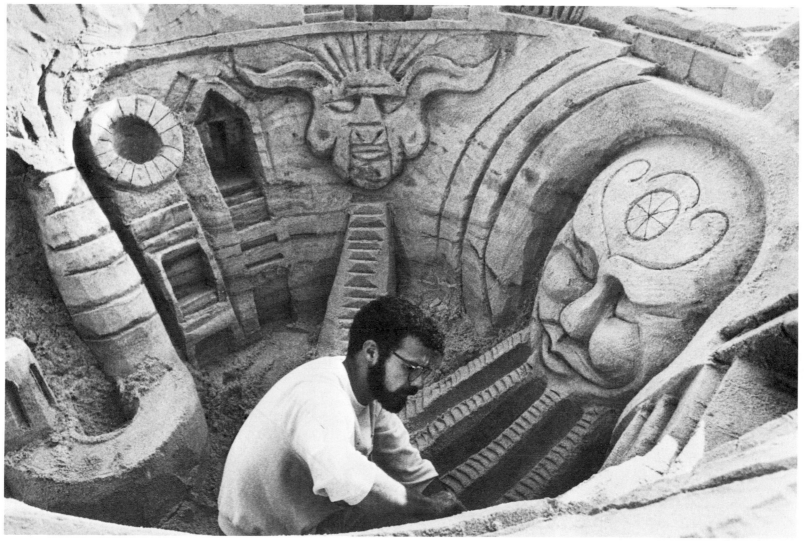

Stuart Goldman

Sandsong *detail*

*After two hours' work, the area is a detailed
conglomerate of many elements from my unconscious.*

69

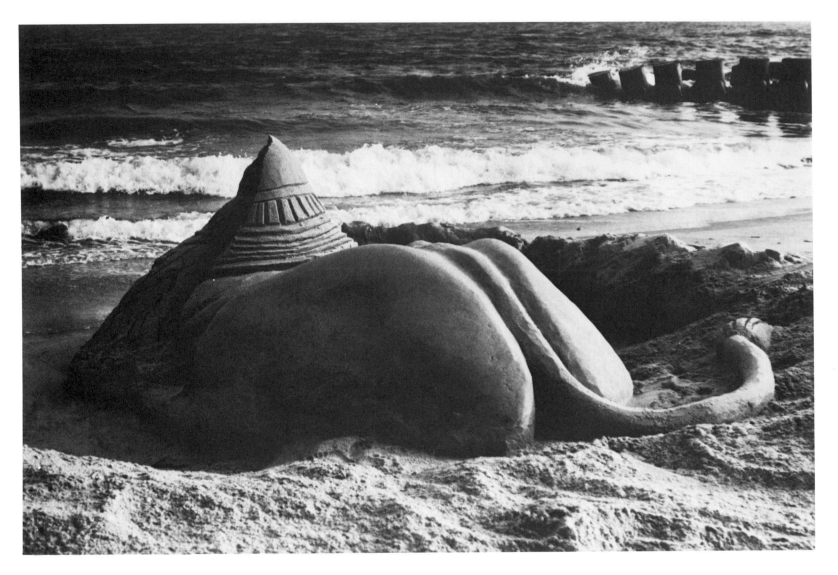

Sphinx *14x7x5'*

Sand sculptors learn to live with collapse.
Before the ocean claimed this head, I had already made three versions.

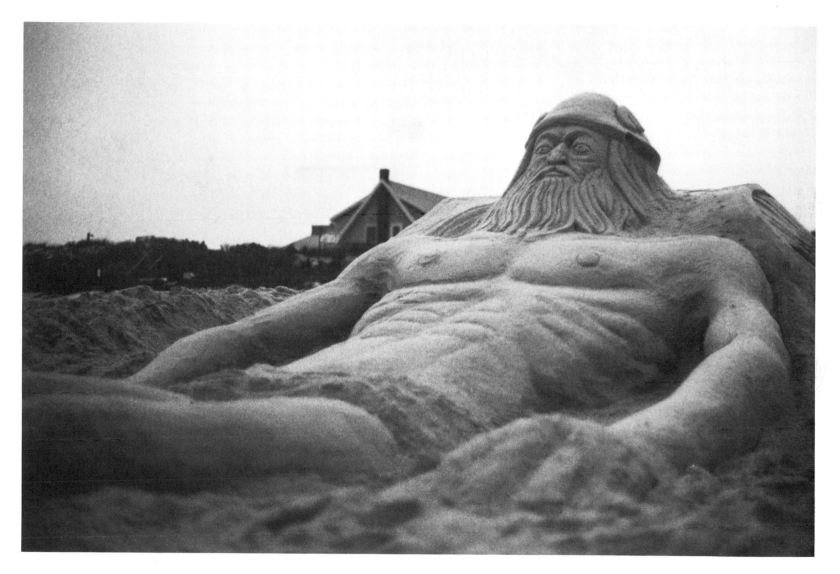

Mercury *15x8x7'*

*This reclining Mercury, messenger of the Gods,
was made in honor of an annual Fire Island marathon.*

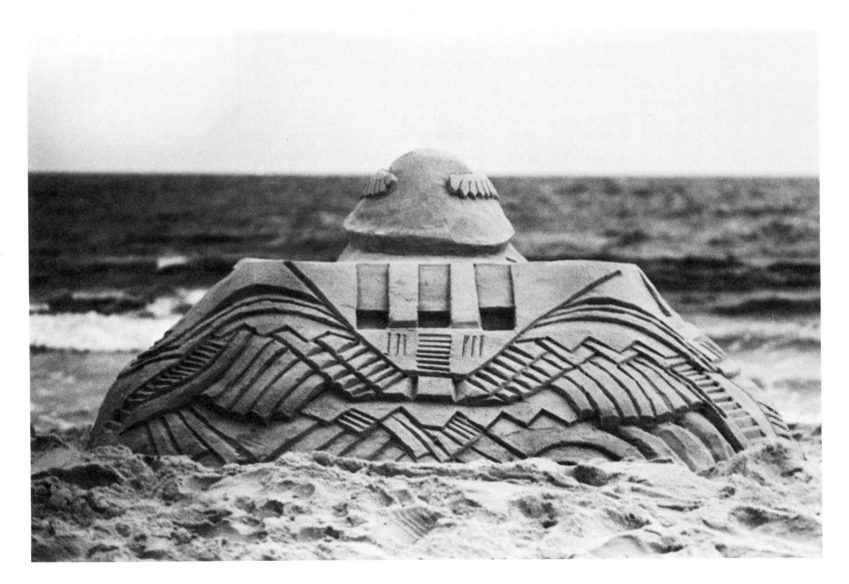

Mercury *detail*

*The throne (seen from the rear) acts as a buttress to support
the enormous figure. The wing motif seemed a natural decoration.*

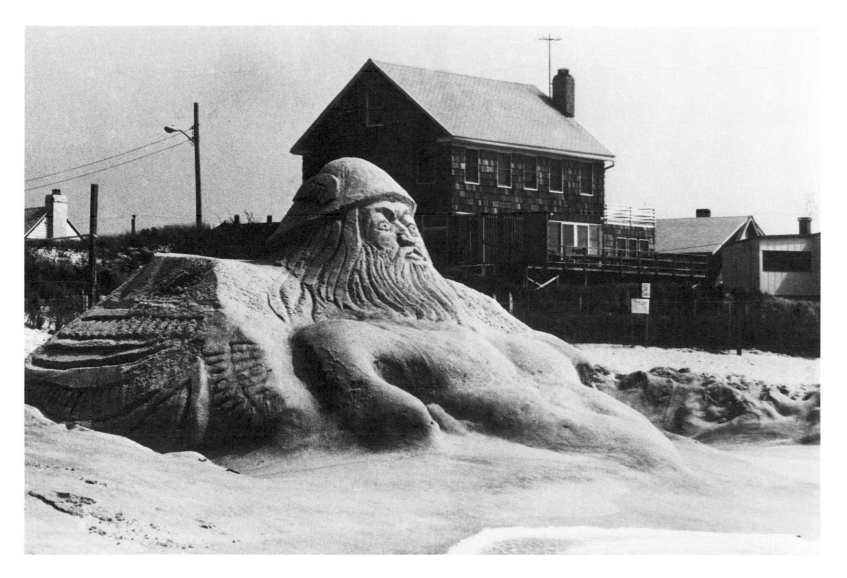

Mercury *detail*

*The remains of the torso became more natural in appearance
as the waves continued to smooth and unify the once detailed form.*

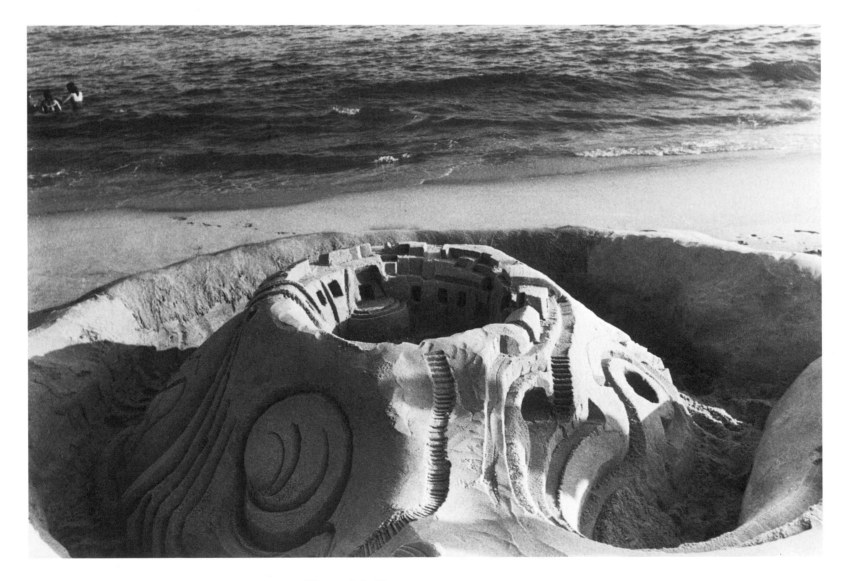

Urn with Faces _rear view, 8' diameter_

When a tide comes in sooner than anticipated, as was the case here,
the rush is on to decorate a relatively unfinished mound.

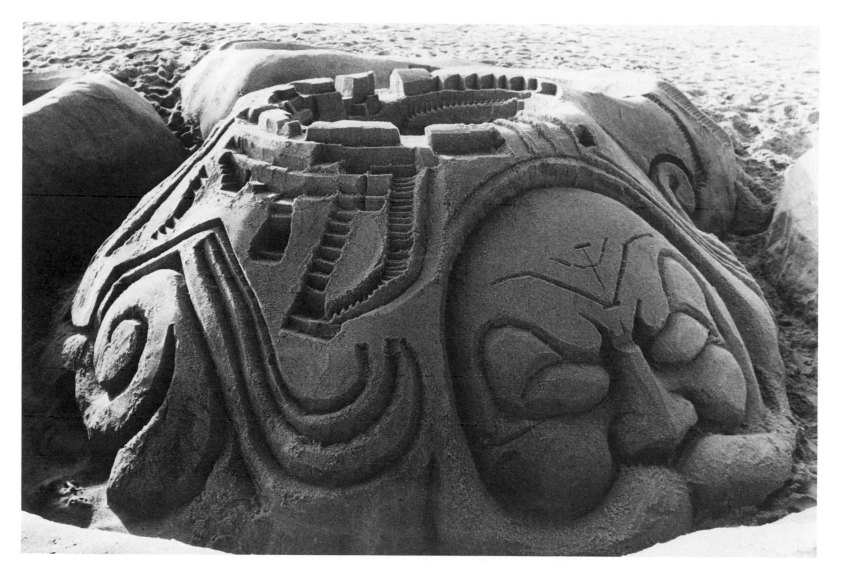

Urn with Faces *front view*

*Sometimes the dissolution of a piece
is more interesting than the sculpture itself . . .*

75

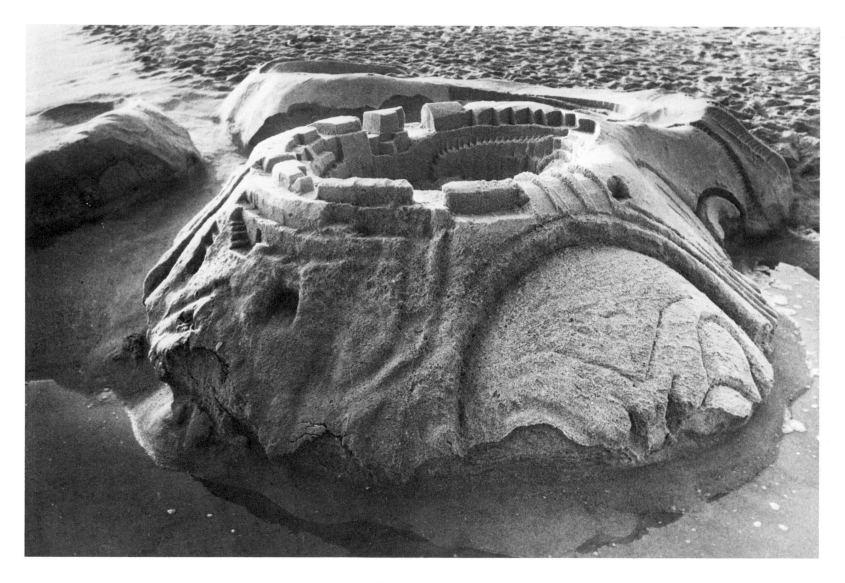

Urn with Faces *front view*

*. . . and here it is half gone. The indistinct and abstracted
contours release viewers to experience their own free associations.*

76

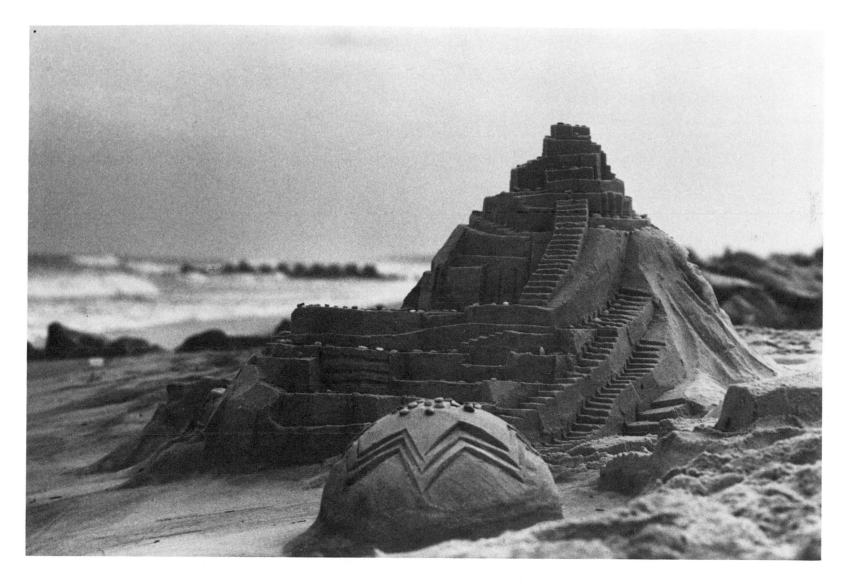

Rock City *10x10x4-1/2'*

Seemingly endless stairs can be easily made by cutting vertically,
then dragging the excess sand towards the next vertical cut.

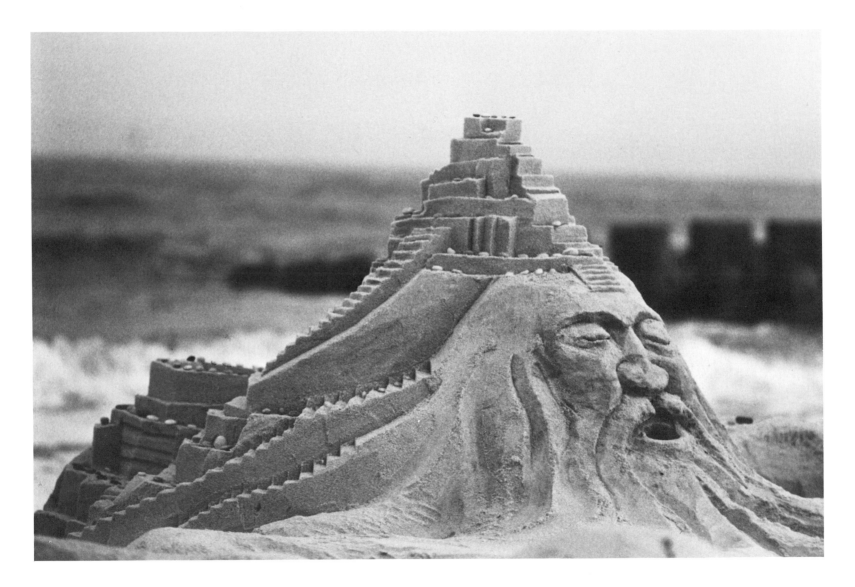

Rock City *detail*

*Adding a face to the city magically changes the scale
of both the city and the face.*

78

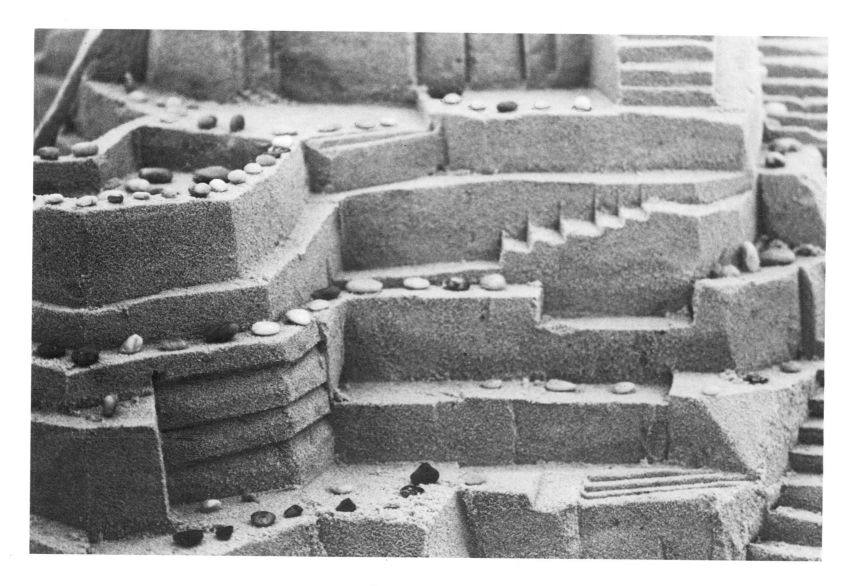

Rock City *detail*

*Multidirectional cutting plays with highlights and shadows
as do the small stones, which were added as an afterthought.*

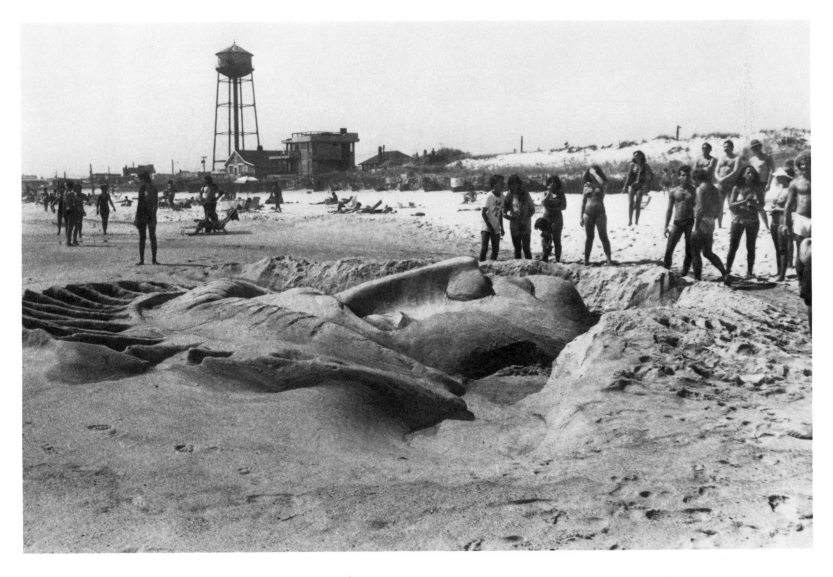

Liberty _25x28x5'_

Liberty has lost the starbursts and is fast losing the windows of her crown.

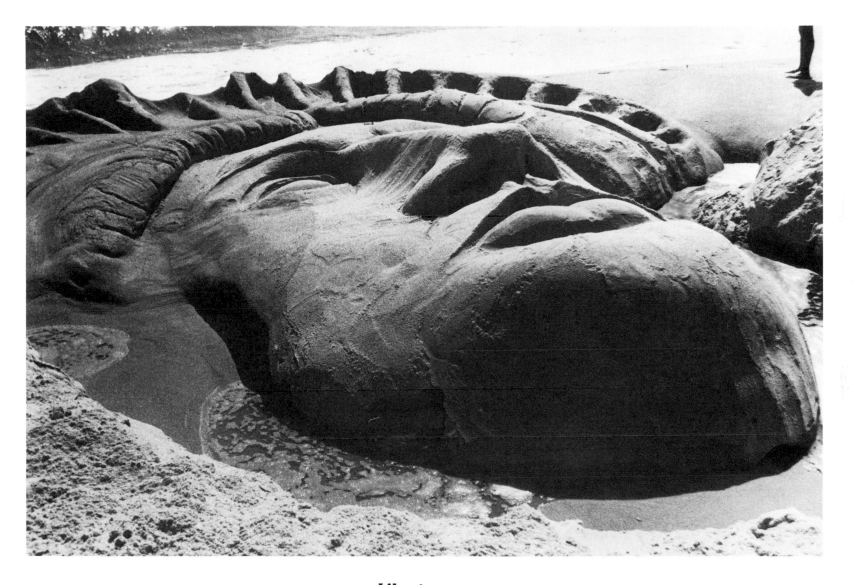

Liberty *detail*

As further erosion takes her away, the delicate nature of our liberty is evoked.

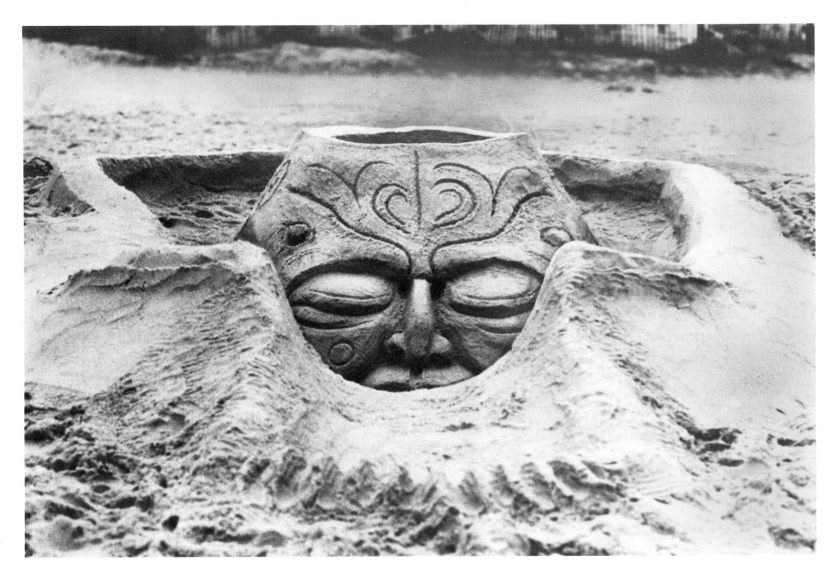

Tattoo'd Urn *6' tall*

*Looking like a recent excavation, this slightly
hidden piece took many beach strollers by surprise.*

82

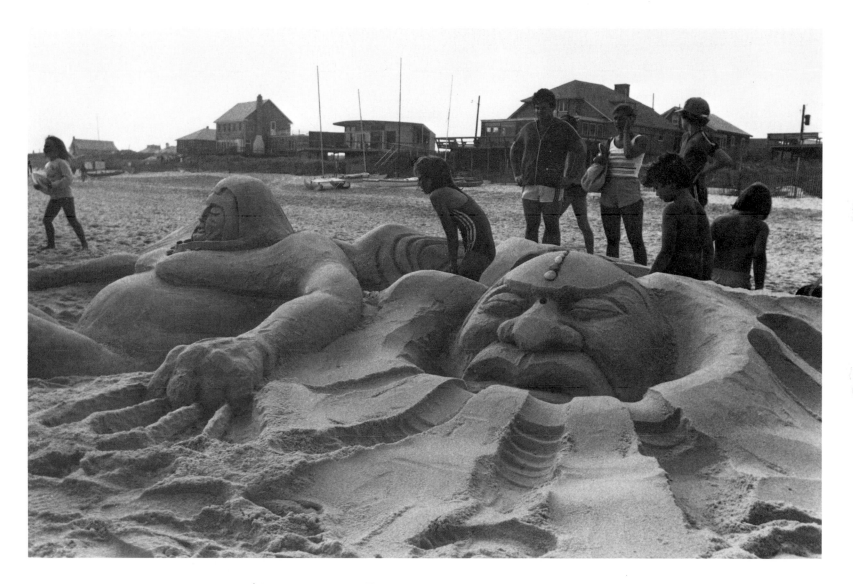

Fantasy *19x20x4'*

*There is easy access to the inner areas of this sculpture
where young visitors take extra care to avoid accidents.*

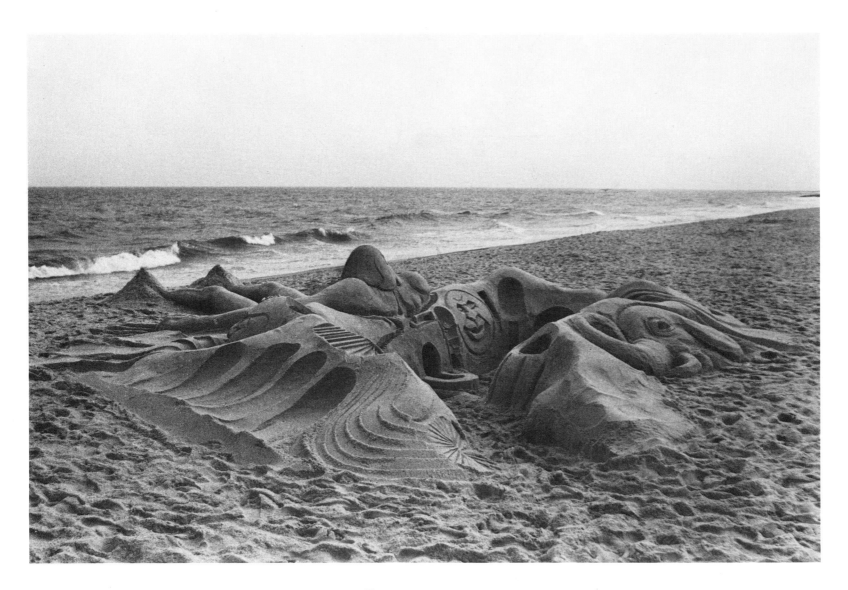

Fantasy *rear view*

*Suggestions and requests from children resulted
in a concoction of real and imaginary elements.*

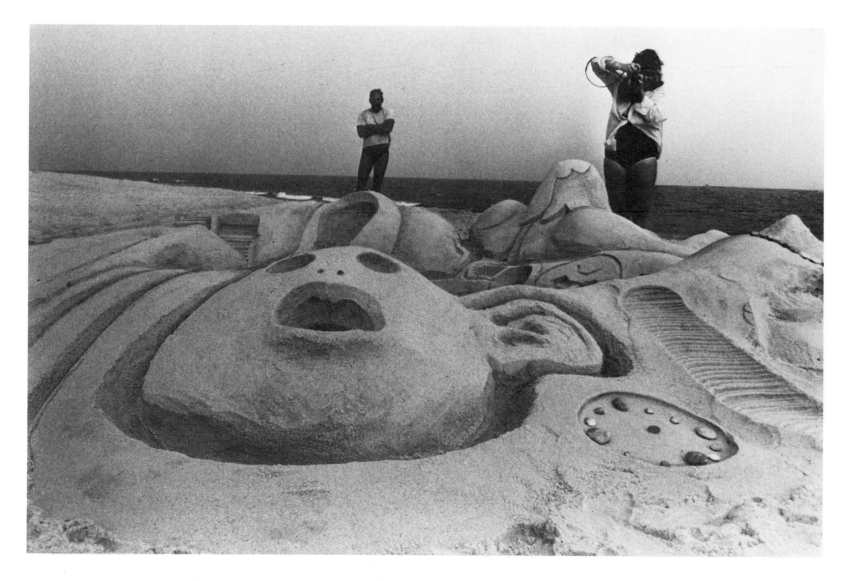

Fantasy *detail*

The face here is borrowed from the well known "Scream" by Edvard Munch.
There is a stone-faced clock in the right foreground.

85

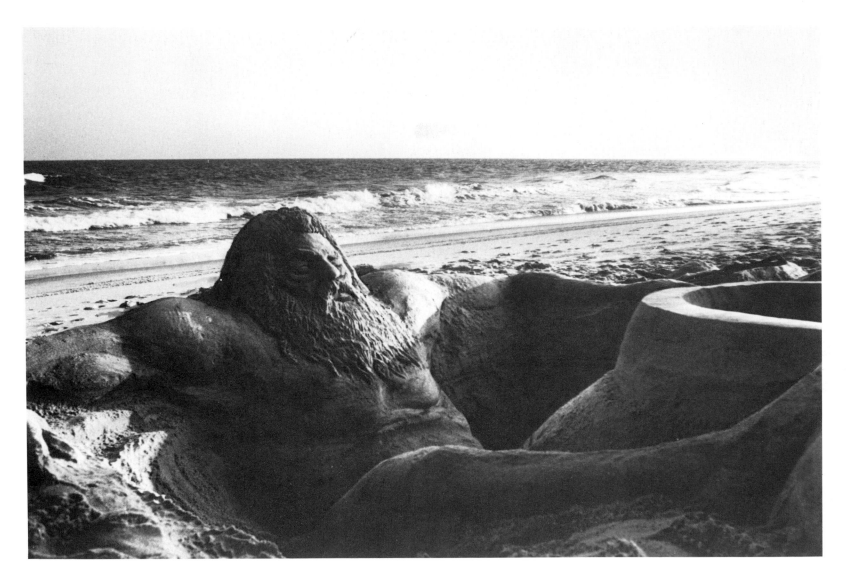

Man with Vase *15x20x6'*

This patriarchal figure sits in a pit with his legs raised and straddling a vase.
His beard is a miniature light and shadow sculpture.

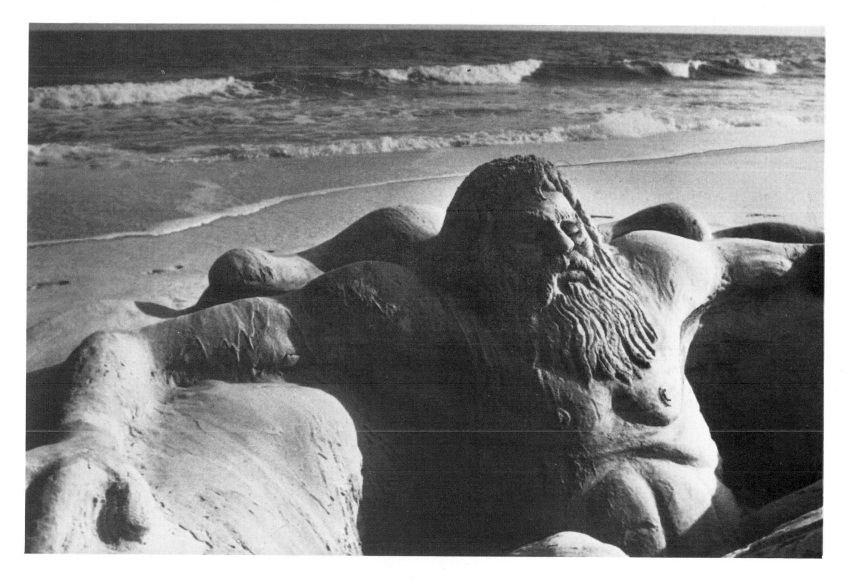

Man with Vase *detail*

The sculpture is now complete with throne and much more refined,
but it's the beginning of the end as the water splashes lace over the man's shoulder.

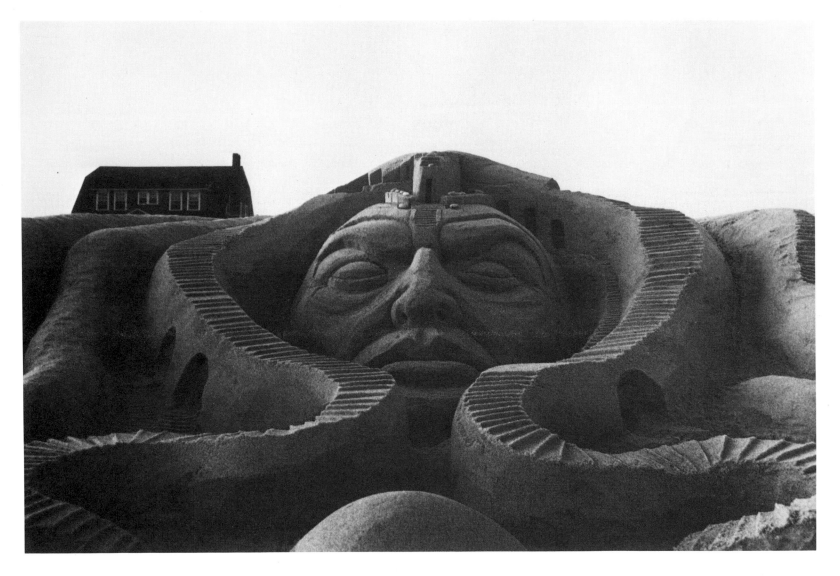

Indian *20x20x5'*

*The tide will sometimes leave a steep ledge from which to carve. The low camera angle here
exaggerates size by juxtaposing the piece against the house some forty yards away.*

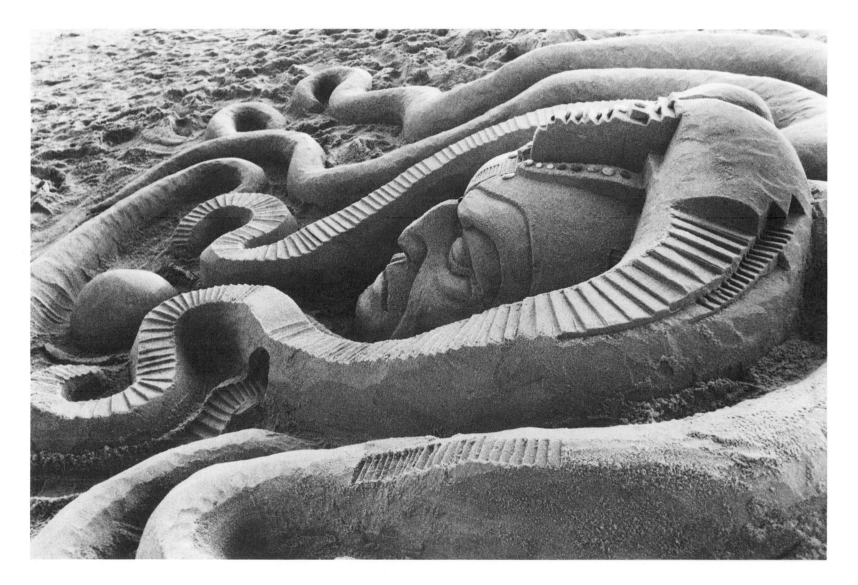

Indian *detail*

*The serpentine motif is a very efficient way to work broad areas
without transporting large quantities of sand.*

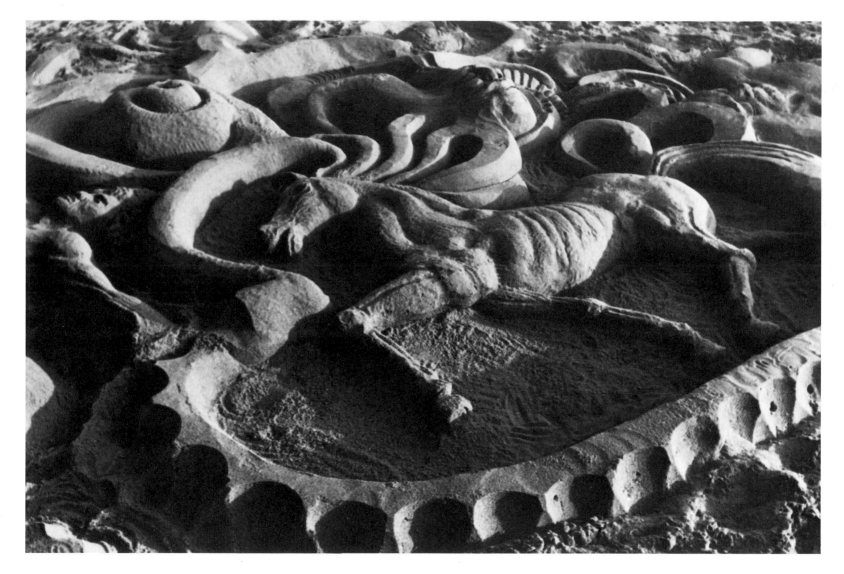

Horse Relief *detail, 15x15x1-1/2'*

Low relief pieces are easy targets for daydreamers,
dogs and runners who see them too late.

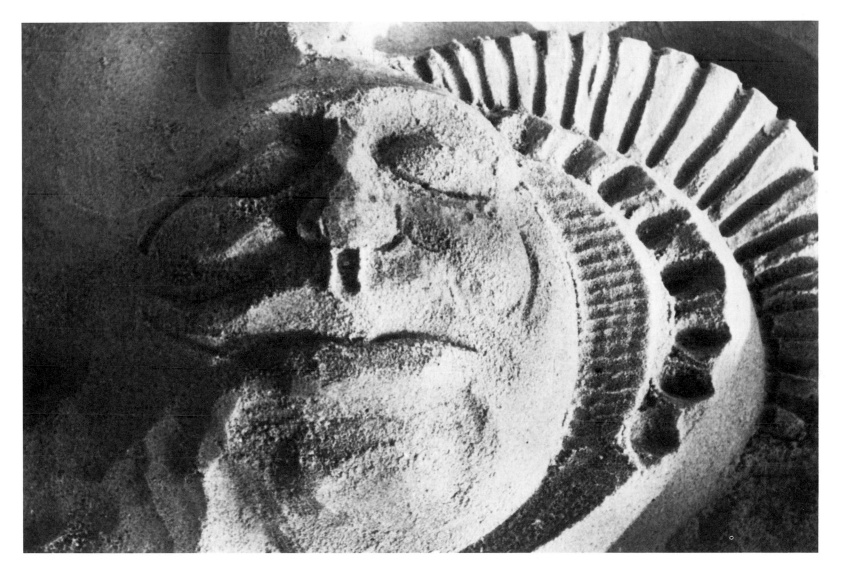

Horse Relief *detail*

*This kind of off-hand "remark" often happens when using rapid construction techniques.
On the previous page, the face can be seen in the horse's mane.*

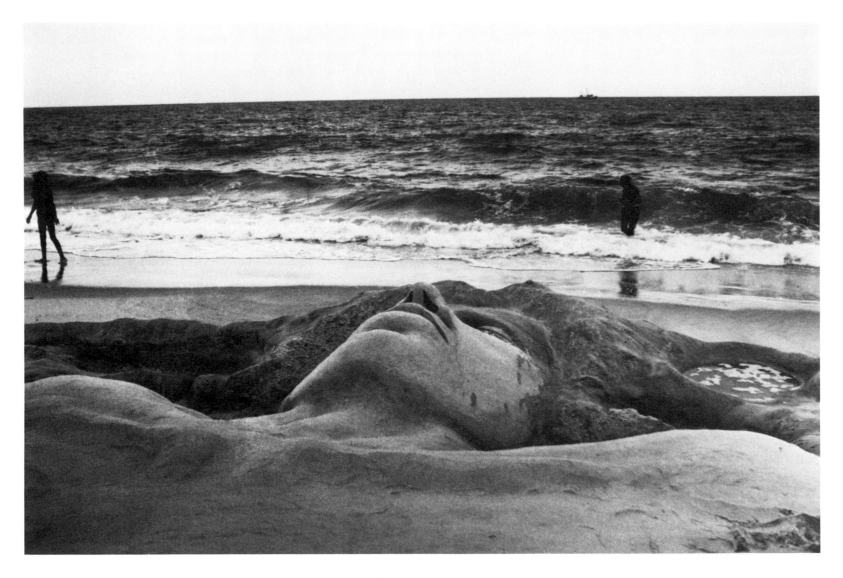

Giant _35x25x5'_

I usually sculpt figures facing the tide.
It seems somehow cruel to deprive this one of seeing its own demise.

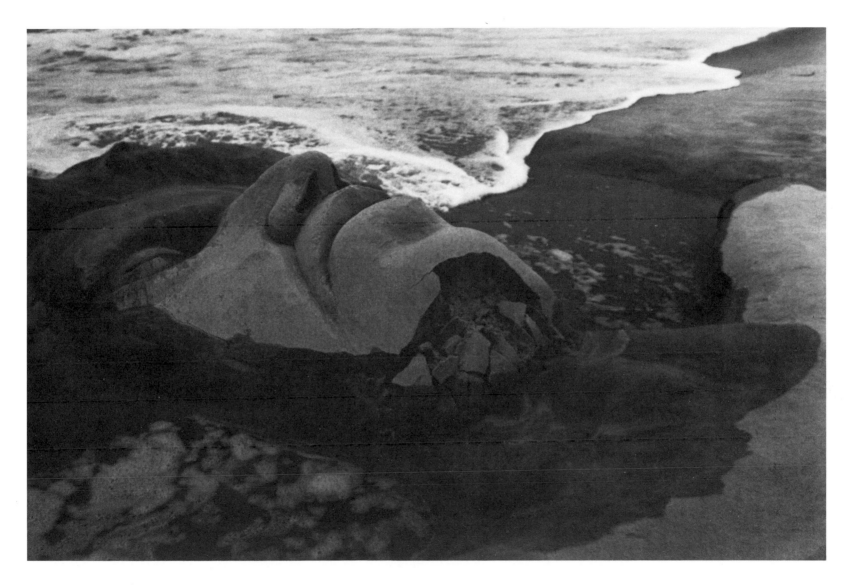

Giant *detail*

*Hours of metamorphosis have filled in the deep spaces
around the head and produced other radical changes.*

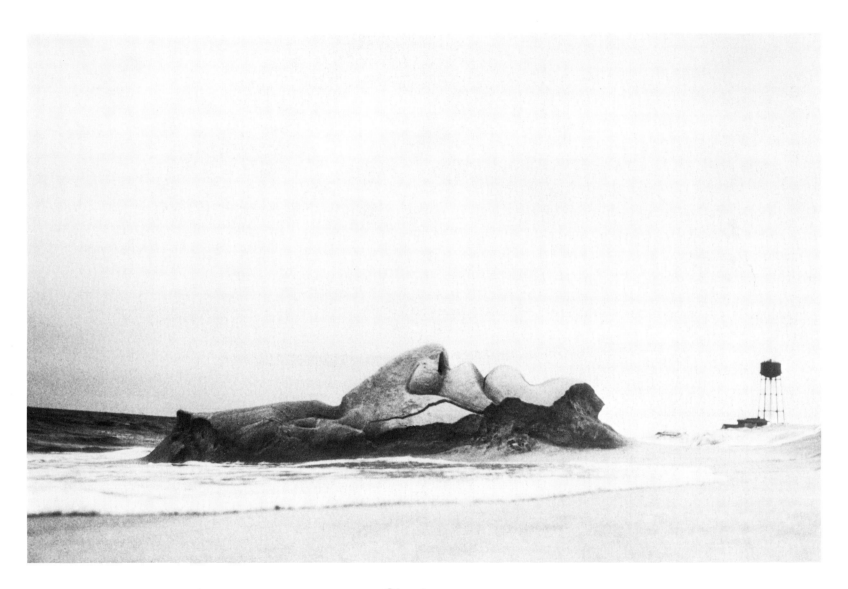

Giant *detail*

*Caught from a nearly ground-level camera angle,
the ruins dominate a distant 150' water tower.*

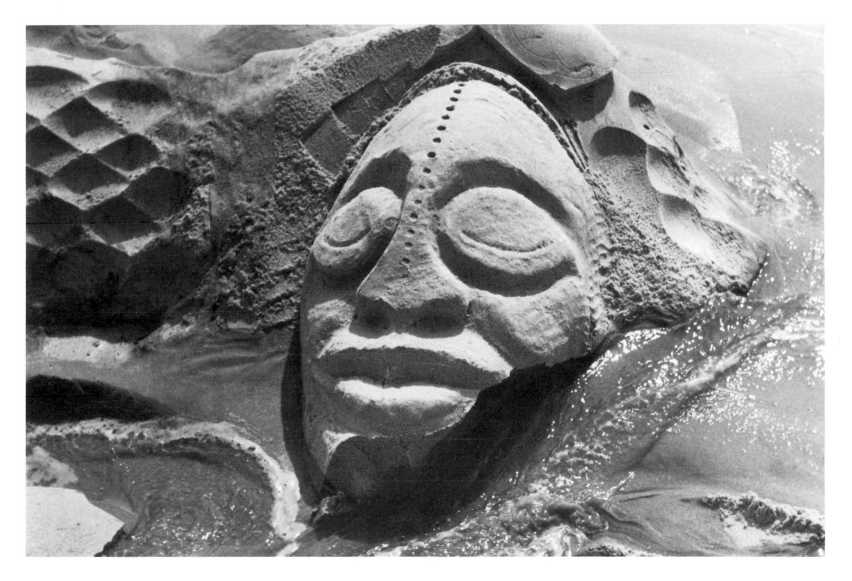

Primitive Mask *4' tall*

This detail of a larger piece evokes traditional art forms.
Deeply undercut by the waves, the cheek may fall at any moment.

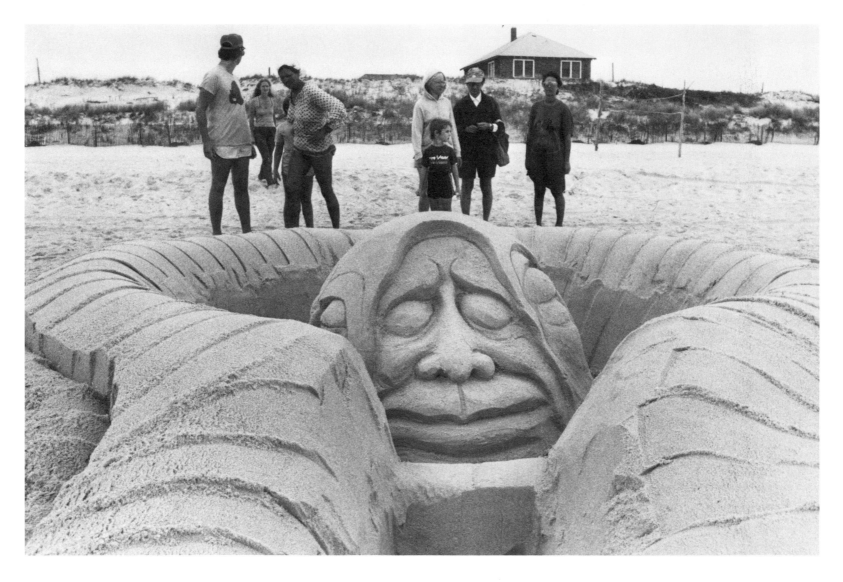

Four Faces *18' diameter area*

A few onlookers anticipate the water coming through the locks of the canal in the foreground.

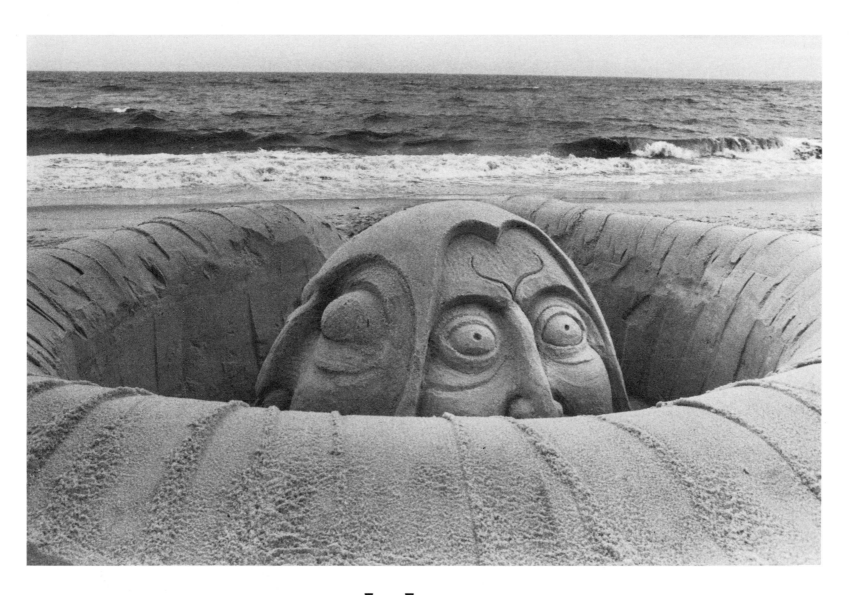

Four Faces *detail*

Each of the four personalities faced a different compass direction.

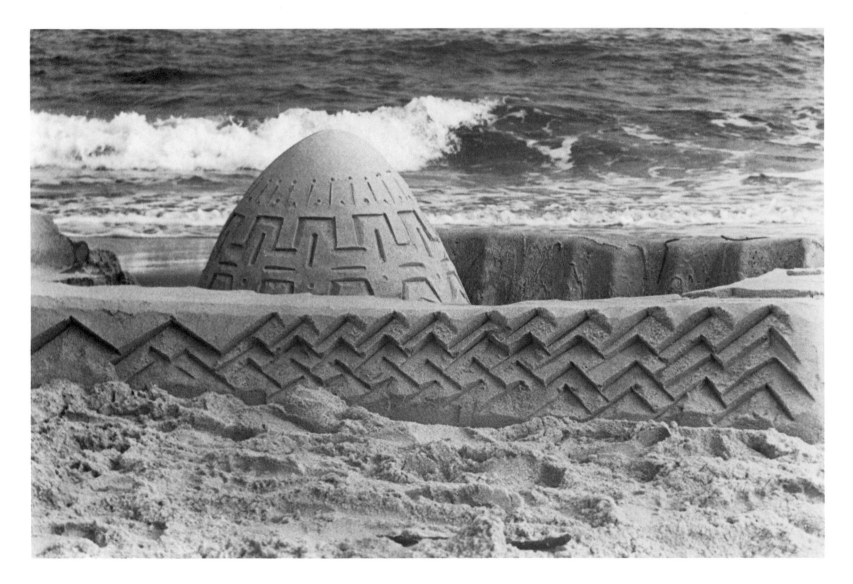

Dome City *10x8x3'*

Repeating designs efficiently decorate broad areas.
The egg shape is very strong until . . .

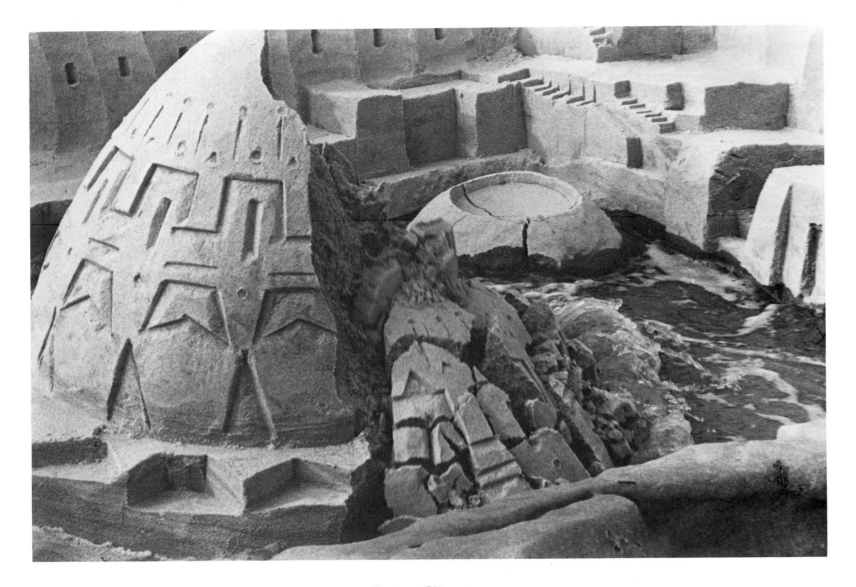

Dome City *detail*

*. . . the water moves in. Here the camera has frozen the moment of collapse
which usually occurs a few seconds after the initial impact of a wave.*

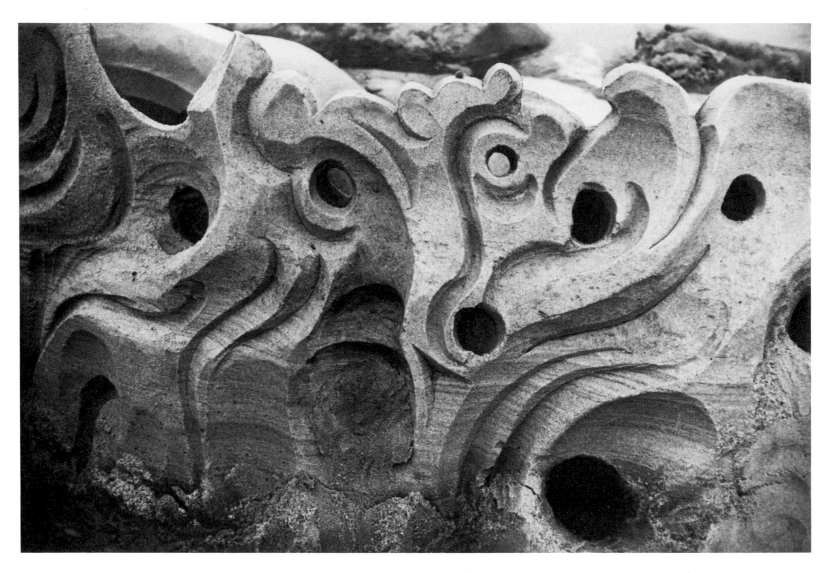

Fire Wall *detail*

*This four-foot wall was designed to interact with small fires whose light could be seen
through the circular windows. We extinguished the flames when the wind made them unsafe.*

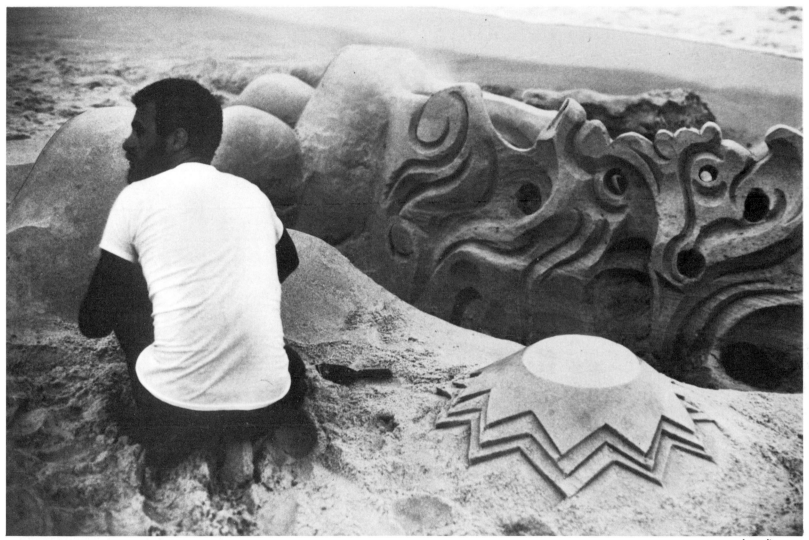

Ines Jimenez

Fire Wall *detail*

*As I worked on some peripheral details,
puffs of curling smoke gave the sculpture a feeling of life within.*

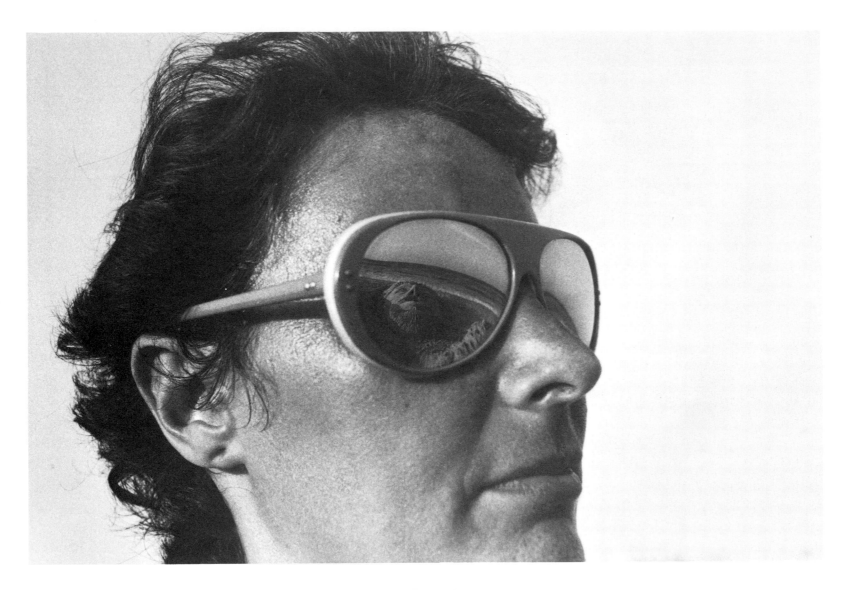

Man with Beard *23x10x5'*

The reflection in the sunglasses of a passerby
belies the actual size of this study of hair and beard.

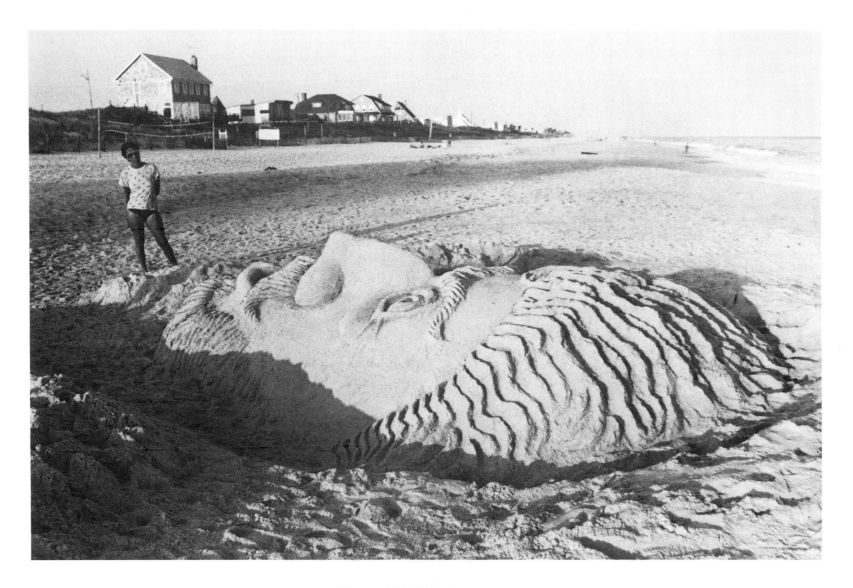

Man with Beard *new view*

*The scales are reversed from this perspective
and we see how, in a sense, you had to be there.*

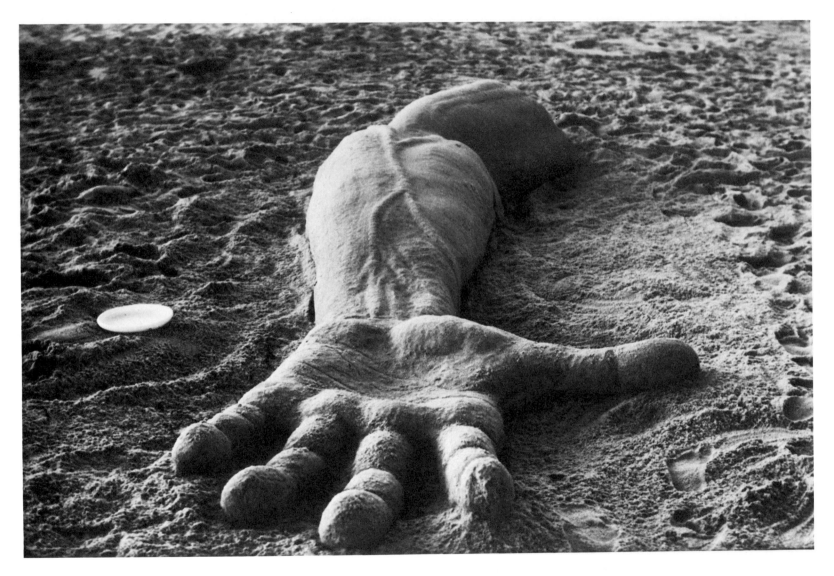

Arm and Hand *22x7x3'*

Veins are fairly easy to make when they are as thick as an actual hand.

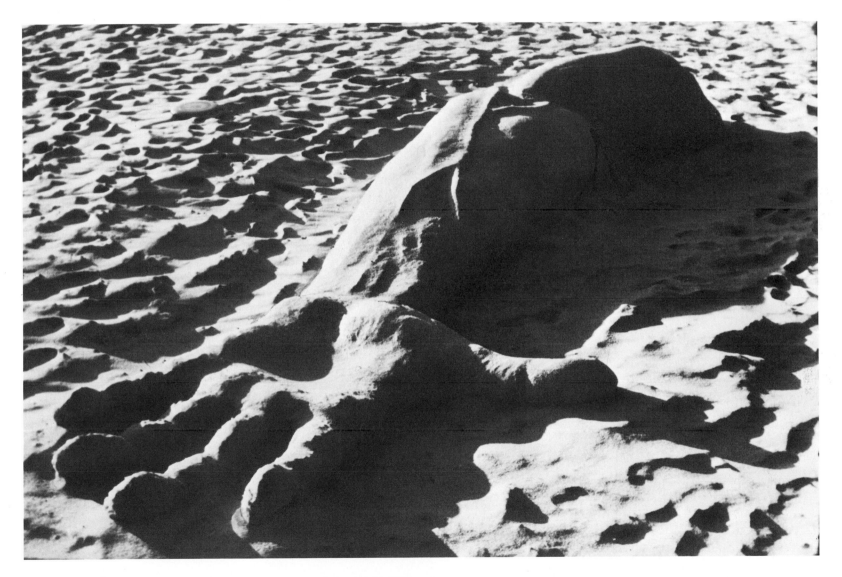

Arm and Hand *metamorphosis*

The effects of high wind and low sunlight sharply alter the mood and character of the piece.

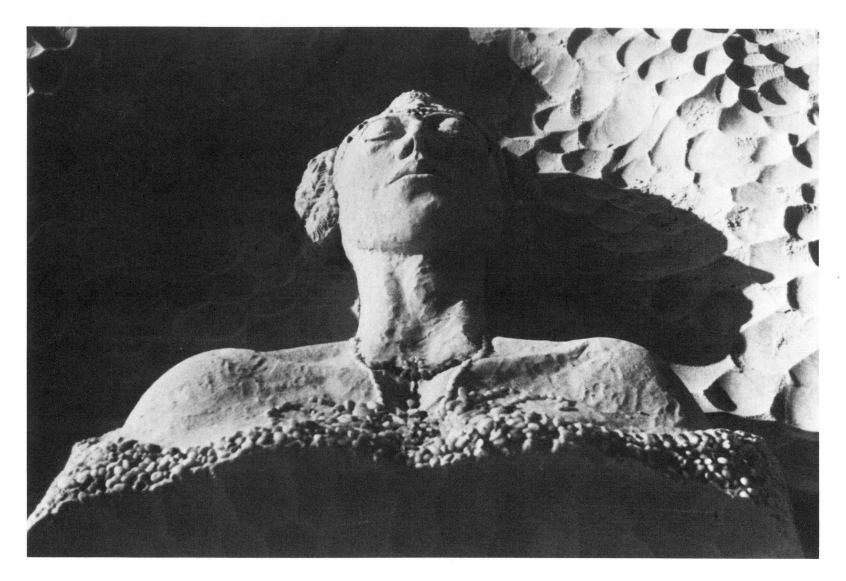

Dutch Lady *6x4x2'*

*Millions of small, multi-colored stones had accumulated on the beach.
I created the woman's head and upper torso to display these jewels.*

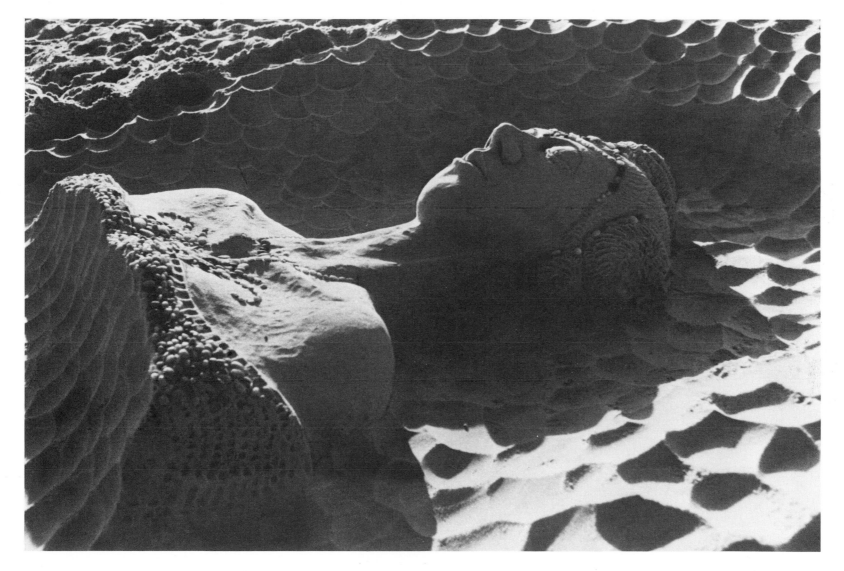

Dutch Lady *detail*

A disc was used to scoop the background texture.
Relaxed, perhaps asleep, she waits.

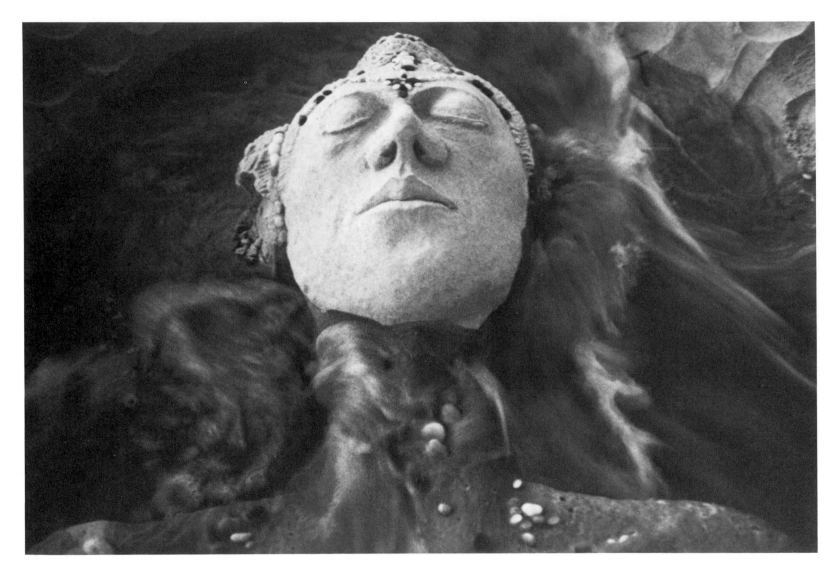

Dutch Lady detail

As the rushing waves are stilled in this photograph, so is her mood suspended.

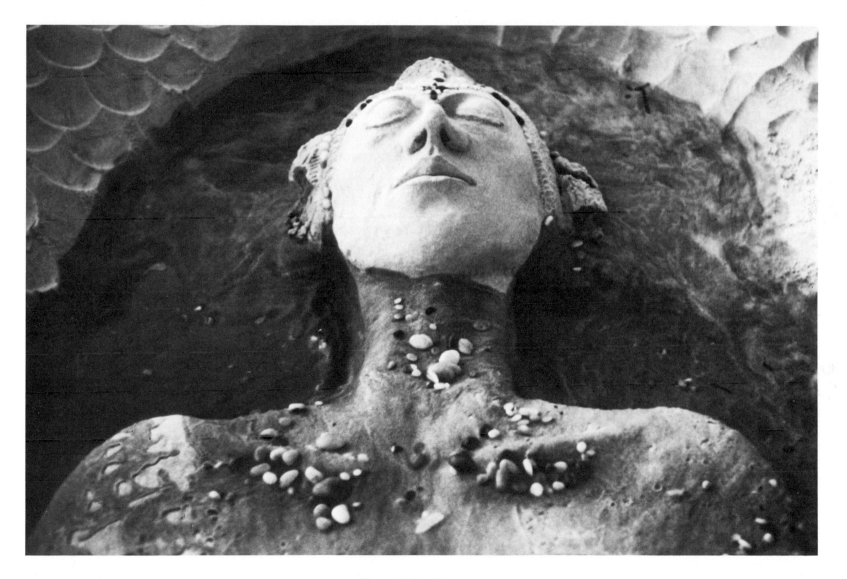

Dutch Lady *detail*

*Her noble face has survived one more assault, but her jewels are in disarray.
The final wave came in total darkness.*

Gerald Lynas is an art director/graphic designer whose award-winning work includes illustration, photography, public relations events, film making, and the design of more than three hundred books, many of them for children.

With partner Stuart Goldman, he is Creative Director of Multi-Media Masters, a film and audio-visual production company with major corporate clients and over twenty industry citations to its credit. MMM's film, *Sandsong*, documenting the life cycle of one of Lynas' sculptures, received the Blue Ribbon at the 1981 American Film Festival and has since earned a dozen international prizes.

Mr. Lynas enjoys working in a variety of non-traditional media, carving heads from fruits and vegetables, painting and drawing on stones, molding huge beasts from snow. One construction, a snow mammoth at the American Museum of Natural History in New York City, made headlines and led to an unusual commission: Lynas was invited by the 1980 Winter Olympic Committee to build snow sculptures. This became a five week creative interaction between the artist and the athletes recorded in another MMM film, *Olympic Village Journal*.

Mr. Lynas graduated with a BFA from the Kansas City Art Institute and has been a long time faculty member at Pratt Institute where he currently teaches a course in communication design. Other passionate interests: the study of music and the classical guitar, playing professional Frisbee®, painting murals, cycling, and working for the preservation of nature. The artist lives in New York City with his wife and two daughters.

Marilyn Meyers is a writer/producer with skills in a wide range of the performing arts. For PBS' New York station, WNET, her responsibilities included developing comedy, poetry and drama, work which led to a series of Irwin Shaw's short stories and to co-editing (with Kenneth Cavander) Theater in America's highly praised production, *The Cheever Trilogy*. While at WNET, Ms. Meyers also wrote a screenplay about the great Latin American authors Pablo Neruda, Jorge Luis Borges, and Gabriel Garcia-Marquez.

Other recent assignments: writing/producing for ABC's Emmy award-winning *Kids Are People, Too*; translating French writer Jeannine Worms' play, *Archiflore;* and contributing comedy material to *Word of Mouth,* a cabaret evening at the American Place Theater in NYC.

Upon receiving a BA, magna cum laude, from Tufts University, Ms. Meyers attended the MFA Program in acting at the Yale School of Drama. In her subsequent ten years as an actress, she appeared with such noted producing groups as the Kennedy Center, BBC Radio, PBS Television, the Lincoln Center Repertory Company, Columbia Pictures, CBS Network, and the New York Shakespeare Festival, where she has also directed, and evaluated plays for future production.

Her collaboration with Gerald Lynas began not long after she happened upon his work at the beach. Coincidentally, they live around the corner from each other in Manhattan.

*Making this book was like making a sand sculpture
except in one important respect: the materials used
cannot be returned at day's end to their source, the Earth.*

*Mindful of that, I give thanks to the trees whose numbers
were made fewer to become the pages of Sandsong.*